"Art can keep beauty
through time
only if she endure,
... so I'll make her fair."

Michelangelo, 1546

"I already have a wife who is too much for me; one who keeps me unceasingly struggling on. It is my art and my works are my children …"

Michelangelo, as reported by Giorgio Vasari, 1568

Head of the Virgin, detail of Michelangelo's first *Pietà*, 1499
(see page 65)

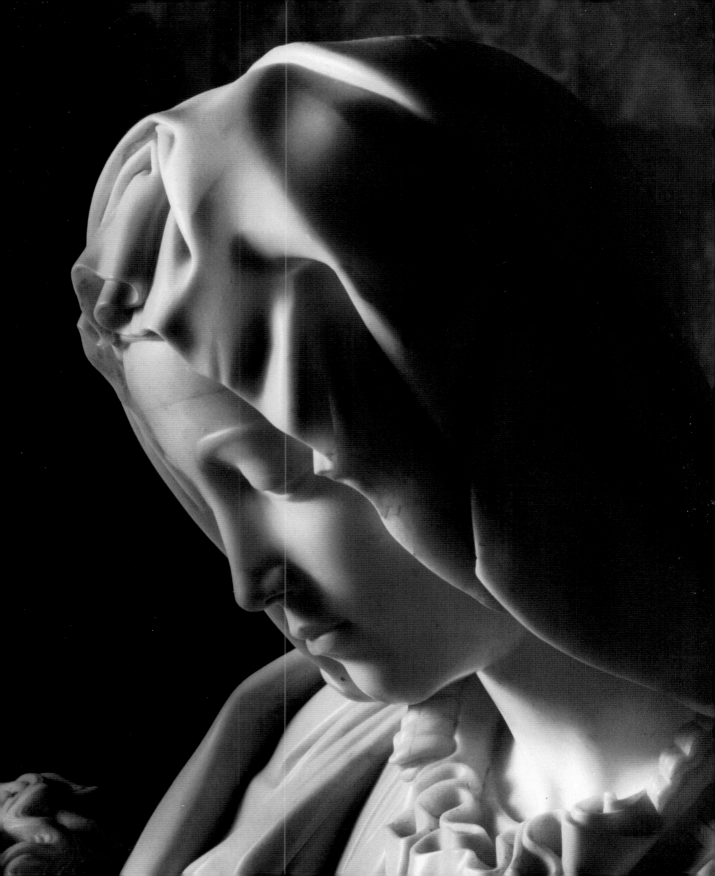

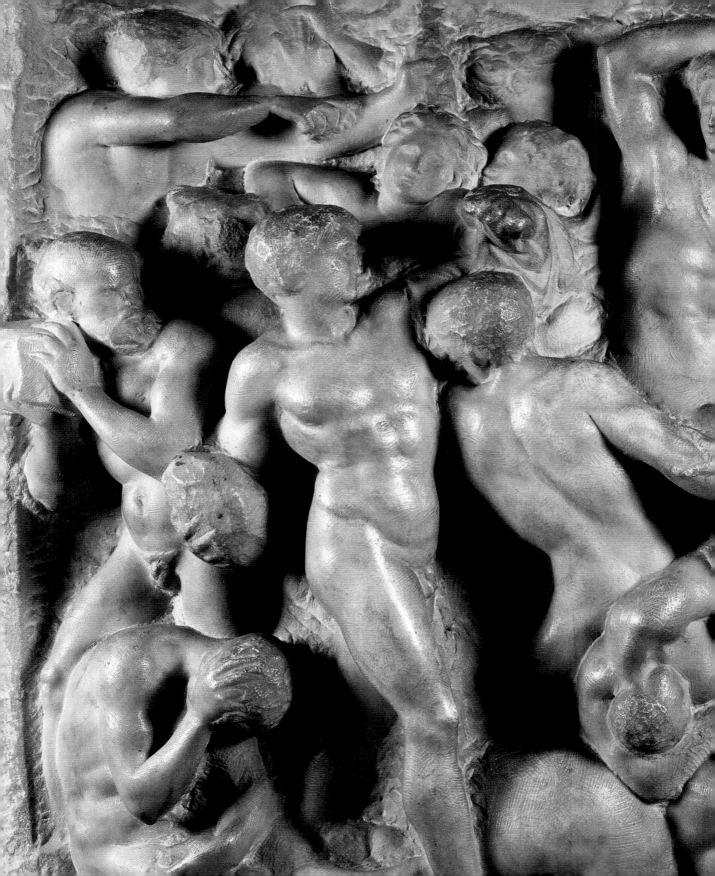

"Sculpture is made by taking away,
while painting is made by adding."

Michelangelo to Benedetto Varchi, 1546

Detail from Michelangelo's second relief, *The Battle of the Centaurs*, 1492
(see page 130)

"I am, of all men who were ever born, the most inclined to love others. Whenever I meet someone who possesses talent or displays dexterity of mind, who can do or say something better than the rest of the world, I cannot help but fall in love with him; and then I give myself up to him so entirely that I am no longer my own property, but wholly his …"

Michelangelo, reported by Donate Gianotti, *c.* 1545

Head of the marble statue of *David*, 1501–04
(see page 66)

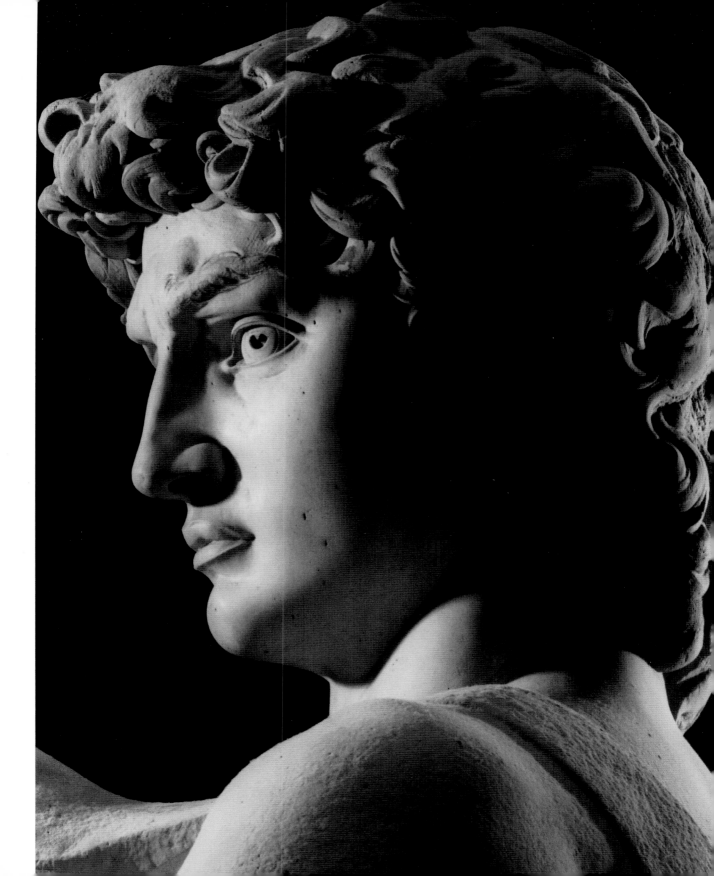

"I was never either a painter or a sculptor like a shop-keeper. I have ever been careful for the honour of my father and of my brothers, although I have served three Popes …"

From *Four Dialogues on Painting* by Francisco de Hollanda (1517–84)

Detail of the marble statue of *David*, 1501–04
(see page 66)

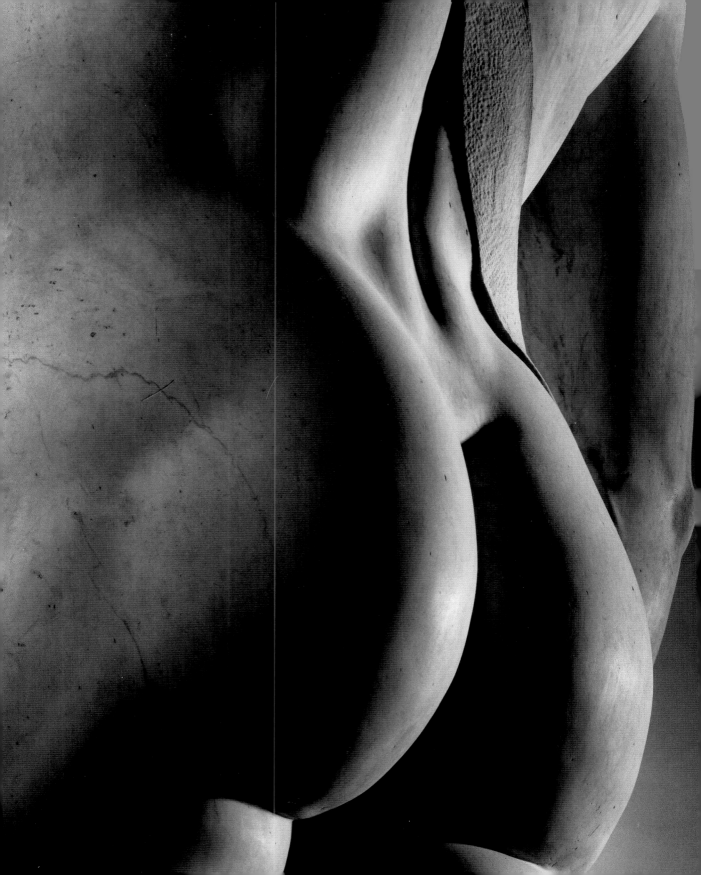

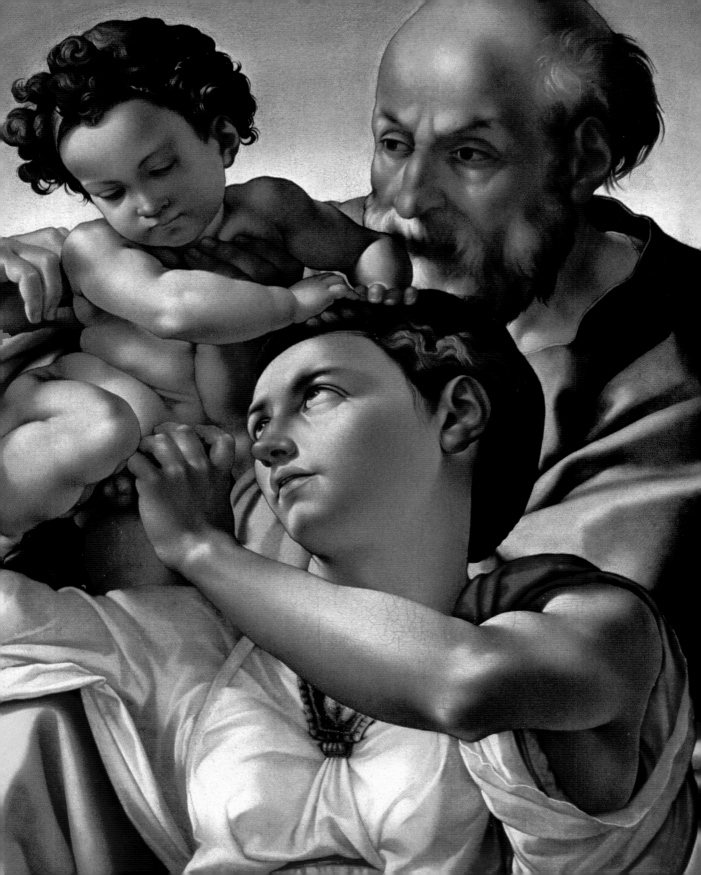

"All the reasonings of geometry
and arithmetic and all the rules of
perspective are of no use without the
compasses of the seeing eye."

Michelangelo in conversation with Giovanni Paolo Lomazzo (c. 1584/85)

Detail of the *Holy Family*, 1504–06, the only surviving completed easel painting
by Michelangelo
(see page 96)

"What one has most to work and struggle for in painting is to do the work with a great amount of labour and sweat in such a way that it may afterwards appear, however much it was laboured, to have been done quickly and almost without any labour, and very easily, although it was not."

From *Four Dialogues on Painting* by Francisco de Hollanda (1517–84)

"Only works which are done in Italy can be called true painting, and therefore we call good painting Italian, for if it were done so well in another country, we should give it the name of that country or province. As for the good painting of this country, there is nothing more noble or devout, for with wise persons nothing causes devotion to be remembered, or to arise, more than the difficulty of the perfection which unites itself and joins God …"

From *Four Dialogues on Painting* by Francisco de Hollanda (1517–84)

Face of a woman, detail of the lunette of *Jacob and Joseph*, 1511–12, Sistine Chapel, The Vatican

"What eternal building is there in this city
that I have not yet plundered and carried off,
without wagons or ships, upon flimsy leaves?"

Michelangelo to Vittoria Colonna, 1545

Study for the Porta Pia, one of the city gates of Rome, *c.* 1561,
Casa Buonarroti, Florence

"Let whoever may have attained so much as
to have the power of drawing know that he holds
a great treasure; he will be able to make figures
higher than any tower, both painted and as statues,
and he will find no wall or side of a building
that will not prove narrow and small for
his great imaginings."

From *Four Dialogues on Painting* by Francisco de Hollanda (1517–84)

Virgin and Child, mid-1520s, Casa Buonarroti, Florence

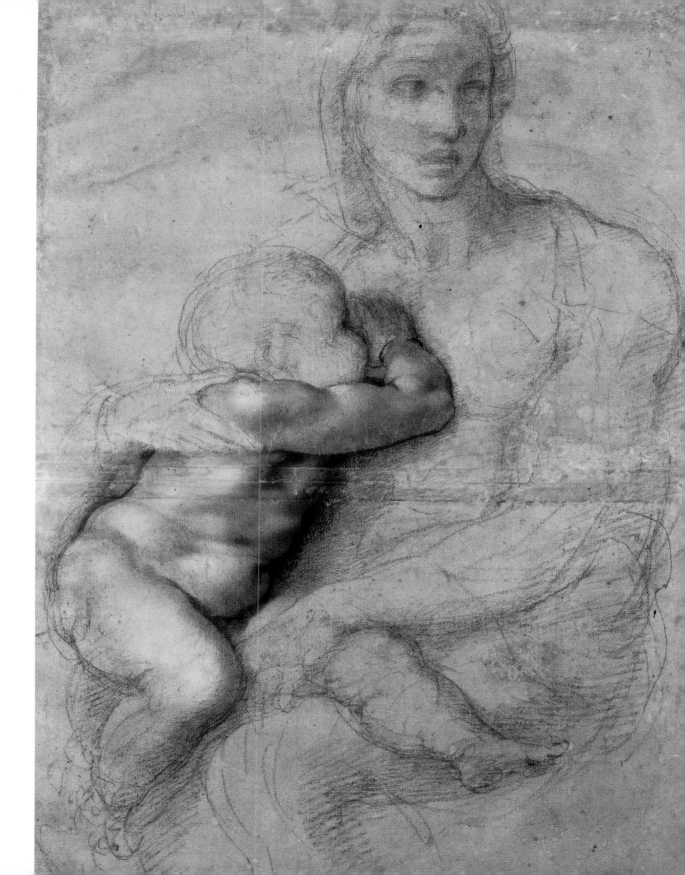

"A good painting is nothing other than a shadow of the divine perfection and an emulation of his painting, a music and a melody that only a noble spirit can perceive, and that only with great effort."

From *Four Dialogues on Painting* by Francisco de Hollanda (1517–84)

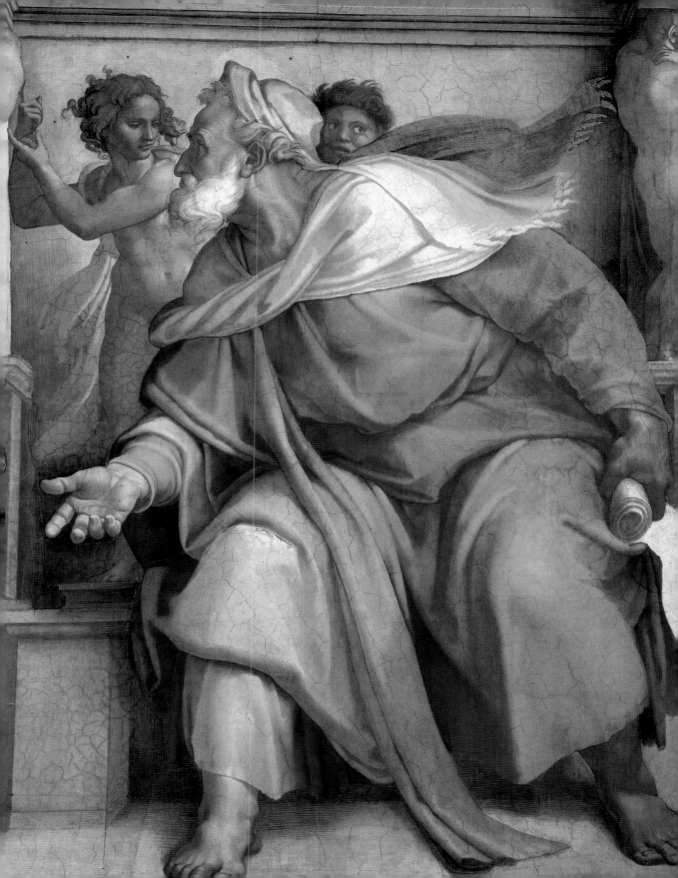

"In the simple drawing of a fish there is as much artistry and imagery as in a drawing of the human figure or, I should like to say, as there is in a drawing of the entire world and all its cities."

From *Four Dialogues on Painting* by Francisco de Hollanda (1517–84)

Study of a dragon, Ashmolean Museum, Oxford

"Beauty depends on purpose.
It is in the elements
best suited to their purpose or aim
that beauty shines forth
most strongly."

Michelangelo in conversation with Vincenco Danti (1567)

Study of a boy, presumably Andreas Quaratesi, *c.* 1532, British Museum, London

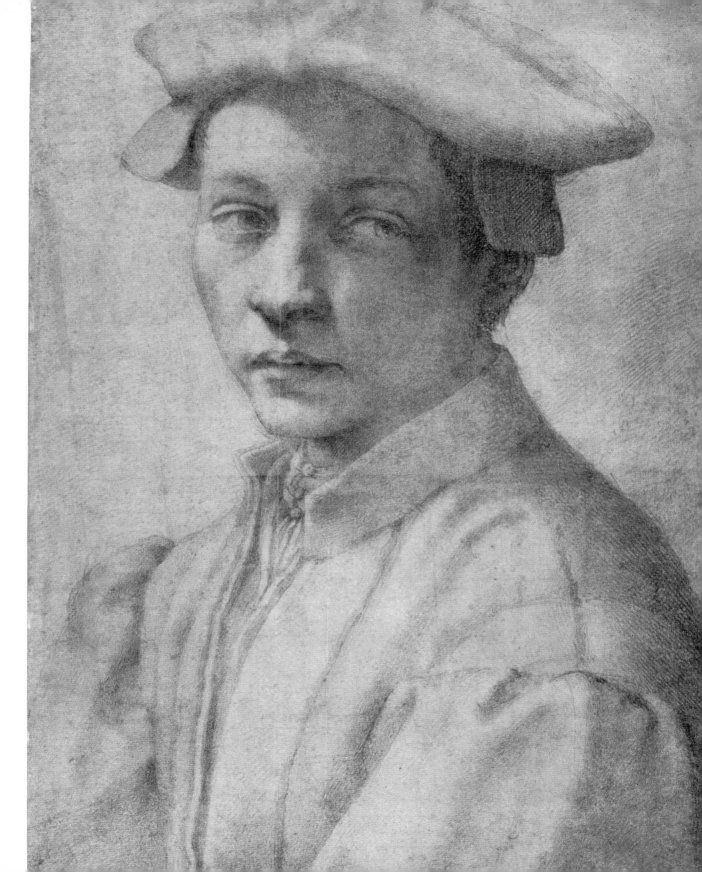

I've got myself a goitre from this strain,
As water gives the cats in Lombardy,
Or maybe it is in some other country;
My belly's pushed by force beneath my chin.

My beard toward heaven, I feel the back of my brain
Upon my neck, I grow the breast of a Harpy;
My brush, above my face continually,
Makes it a splendid floor by dripping frown.

My loins have penetrated to my paunch,
My rump's a crupper, as a counterweight,
And pointless the unseeing steps I go.

 In front of me my skin is being stretched
While it folds up behind and forms a knot,
and I am bending like a Syrian bow.

And judgment, hence, must grow,
Borne in the mind, peculiar and untrue;
You cannot shoot well when the gun's askew.

Giovanni, come to the rescue
Of my dead painting now, and of my honour;
I'm not in a good place, and I'm no painter.

Michelangelo to Giovanni da Pistoia

Michelangelo's manuscript of a sonnet about his work on the Sistine Chapel,
with a caricature of himself painting the ceiling fresco, 1509–10,
Archivio Buonarotti, Florence

I o gia facto ũgozo ĩquesto stẽto

chome fa lacqua agacti ĩlonbardia

ouer daltro paese che si sia

cha forza luẽtre apicha socto meto

I abarba alcielo ellamemoria sento

ĩsullo scrignio especto fo darpia

e spennel sopraluiso tuctauia

melfa gocciando ũ richo pauimeto

E lobi entrati misõ nella peccia

e fo delcul p chotrapeso groppa

e passi seza ghochi muouo ĩuano

D imāzi misallũga lachorteccia

e p piegarsi adietro siragroppa

e tẽdomi comarcho soriano

po fallacĩ e strano

surgie iludicio ĉh lamẽte porta

ĉh mal sitra p cerboctana torta

lamia pictura morta

di fedi orma giouanni elmio onore

nõ sẽdo ĩloco bõ ne io pictore

"I live here in great discomfort and hardship and have no friends, nor do I want any; and I do not even have time to eat. So I have no wish to be burdened with still more problems, for I could not bear another ounce."

Michelangelo to his brother Buonarotto in Florence (1509)

Bartholomew with his skin, detail of the *Last Judgment*,
Sistine Chapel, The Vatican
(see pages 98 f.)

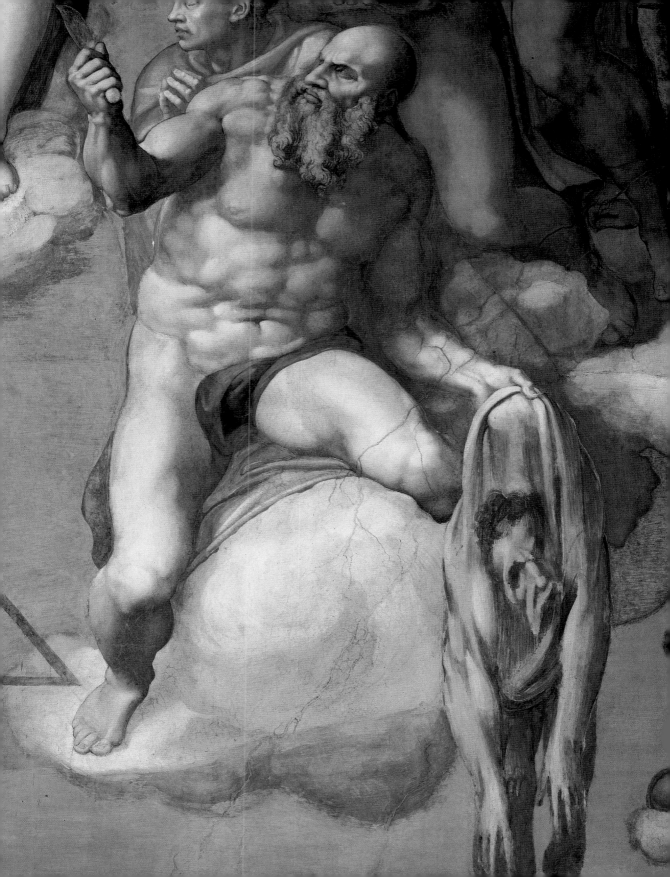

Relieved of a troublesome and heavy corpse,
and set free from the world, I turn to you,
my dear Lord, as a tired and fragile boat
heads from the frightful tempest toward sweet calm.

Your thorns and your nails and both of your palms,
and your benign, humble, and merciful face,
promise to my unhappy soul the grace
of deep repentance and hope of salvation.

May your holy eyes not look upon my past
with justice alone, nor likewise your pure ear,
and may your stern arm not stretch out to it.

May your blood suffice to wash and cleanse my sins,
and the older I grow, the more may it overflow
with ever-ready aid and full forgiveness.

From Michelangelo's last sonnets

Study of Christ on the Cross with the Virgin and St John, British Museum, London

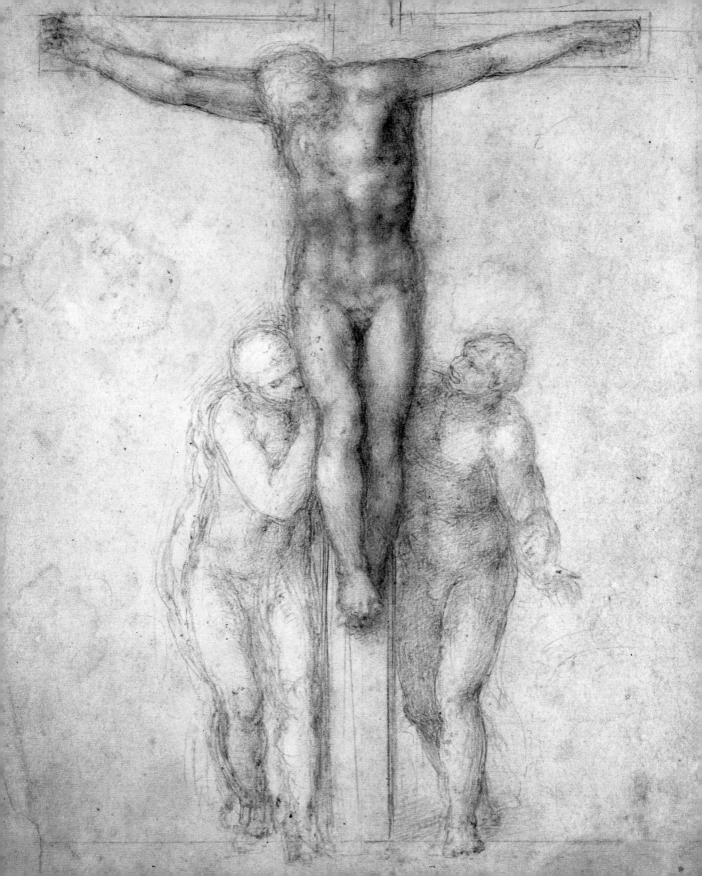

I, Michelangelo

By Georgia Illetschko

PRESTEL

Munich · Berlin · London · New York

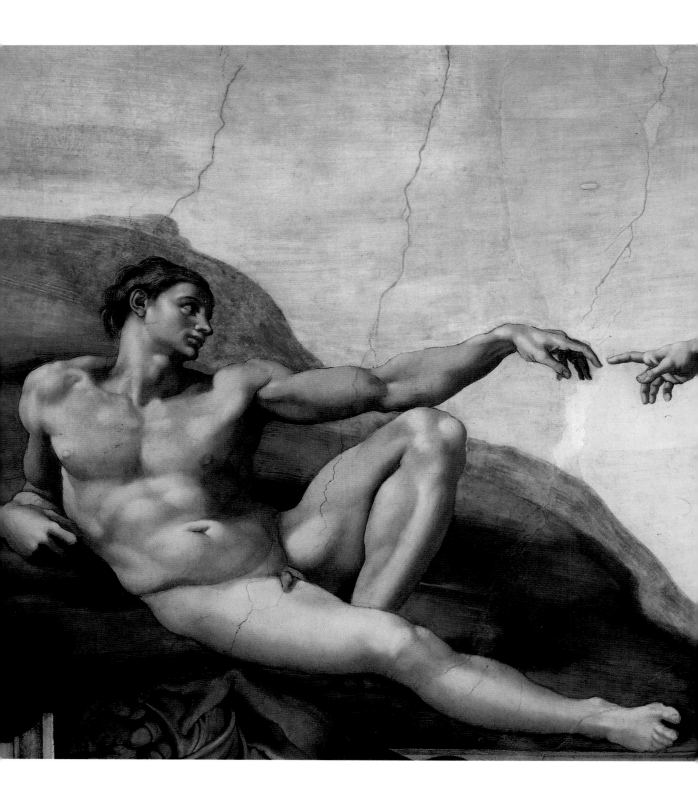

Contents

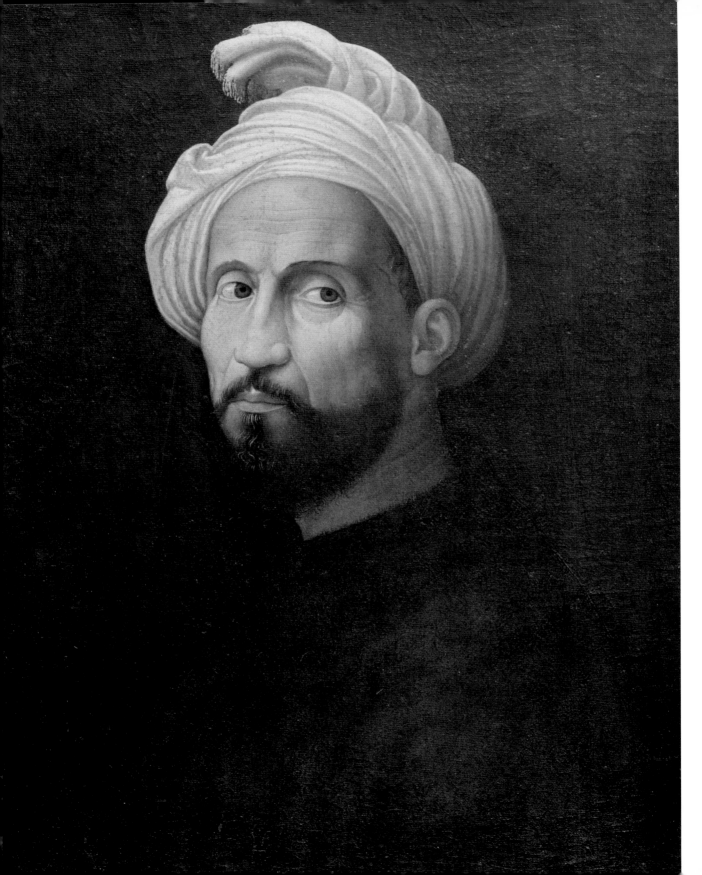

I, Michelangelo Buonarroti

Lionardo,

*I received your recent consigment of the twelve fine and good Marzolino
cheeses: I thank you for them and my gratitude is further enhanced by my
joy that you are well, as I am too. If I have received several letters from you
recently without replying it is because my hand no longer does my bidding.
But from now on I shall have others write for me and simply add my signa-
ture. I have no other news to report.*

Rome, 28 December 1563

I, Michelangelo Buonarroti

The last letter written by Michelangelo at the age of almost 89 shows him to be a lucid
old man of sharp wit, contented with life in spite of his frailty, and still able to enjoy
such pleasures as a gift of Tuscan cheese. Right up until a few days before his death on
18 February 1564, he was still venturing out, even making the effort to go horse-riding
as he so often did in fine weather, and continuing to work on his *Pietà*. The last words,
written in a remarkably steady hand, seem to resound like the self-affirming call of a
man who does not doubt his own outstanding status as an artist revered in his own life-
time as 'divine'. And yet we find him saying *I, Michelangelo Buonarroti* only three times:
in the letters to his nephew and heir, "Dearest Lionardo Buonarotti, like a son to me, in
Florence." It is an expression of almost tender intimacy couched in the earnest offi-
cialese of a last will and testament, penned at a moment when the Florentine merchant
Buonarroti, sensing that the end was near, sought to put his house in order.

The first letter written in this vein, in January 1546, when Michelangelo was seriously
ill, is about money transfers and real estate purchases. His next letter, written in rude
good health, is in the gruff tone of a grumpy old uncle complaining vociferously about
his sponging relatives: "You have been living out of my pockets for forty years or more
and I have never received a good word from you, let alone anything else … "

Michelangelo took on the role of *pater familias* as a young man, supporting his four
feckless brothers and his unsuccessful father more or less single-handedly. Ironically, he
did so through his art – a pursuit so utterly disdained as a lowly artisanal craft by his
father and uncle that they tried to beat such nonsense out of him when he was a boy,

Michelangelo's last letter, signed Io Michel-
agnolo Buonarroti, dated 28 December
1563, Archivio Buonarroti, Florence.

opposite page:
Giuliano Bugiardini, *Portrait of Michel-
angelo Buonarroti with a Turban, c.* 1522,
oil on canvas, 55.3 x 43.5 cm,
Casa Buonarroti, Florence.

considering it to be beneath the station of any member of such an ancient and respectable Florentine family of merchants, money-changers and officials, even one that had fallen on hard times. Michelangelo, however, was willing to forgo all creature comforts for his vocation, saving cannily and working devotedly towards his vision of restoring the status of his 'most noble family'. Although the Buonarroti family had always belonged to the republican Guelph party, it became increasingly important to Michelangelo that they were, as he erroneously believed, descended from the ancient family of the counts of Canossa.

With the rise of the mercantile family into the aristocracy, he followed the same trajectory, albeit on a more modest scale, as the Medici dynasty – a frame of reference for Michelangelo all his life – had done over several generations. In 1515 he was even granted the right to include the typical *palle* (spheres) in his family coat of arms. In all of this, there is something of the father figure of Lorenzo de Medici, that radiant idol of Michelangelo's youth, who was not only devoted to the arts, philosophy and literature, but who also guided his family business and the political affairs of the city of Florence with a keen mind and a steady hand.

Michelangelo's letters, written over the years, full of instructions and advice on his nephew Lionardo's choice of a suitable bride, so crucial to the family fortunes, also reflect a certain dynastic thinking: neither her dowry nor her looks should play a role, but "only health of soul and body, nobility of blood, and her character and the relatives she has, which are quite important."

The subsequent birth of an heir to his nephew was to be the greatest joy of his old age. The lesser joys, in which he took such pleasure, included the gifts of cheese, Trebbiano wine and other products sent to him from his Tuscan estates. He would distribute them among his friends and patrons in Rome with all the pride of a patriarch, as he did, for instance, on receiving a barrel of pears:

"… there were eighty-six in all. I sent thirty-three of them to the Pope; he seemed well pleased with them." The image that springs to mind is that of a seventy-three-year-old man carefully counting out the pears and choosing the finest for the Pope. The true son of a merchant family, he cannot but count them, checking to see whether the driver might have pocketed some. Even in negotiating contracts, he proves a meticulous businessman with a keen eye for detail who keeps track of every penny. The creative genius that takes wing in his artistic visions of projects so ambitious as to seem almost unfeasible is at the same time firmly rooted in the small details of everyday life, anchored in worldly concerns. He takes comfort in book-keeping and in drawing up lists – be it the detailed accounts for the construction of S. Lorenzo *(left)*, the trousseau for his niece Francesca or the laundry list. Nothing escapes his notice, neither the "two scudi for yarn for the short coat" nor "one bed-sheet, one rod and three-and-a-half ells long, with filet work" and "three-and-a-half ells wide".

Last page of an invoice drawn up by Michelangelo for the Sagrestia Nuova, San Lorenzo, Archivio Buonarroti, Florence.

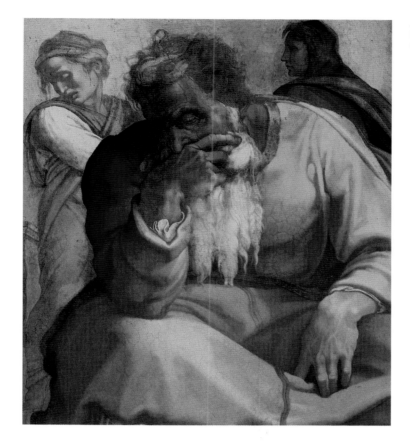

Jeremiah, probably a self-portrait of Michelangelo, detail from the Sistine Chapel Ceiling.

While counting pears and linen may appear small-minded, it actually betrays a touching regard for the little things in life and, with that, a love of life in all its mundaneness. The abundant pleasure that Michelangelo took in earthly things can still be felt even when his 'official' poems and letters are infused with much world-weary soul-searching and a yearning for the afterlife. As an old man, he still warms to the pride and quiet contentment of a flourishing estate, with country homes and town houses – "a decent house in town brings great honour, being more in the public eye than a country house." Though he finds security in the substantial fortune he has amassed in the course of half a century to the greater honour of his family, he does not wallow in it openly. Having experienced in his youth the flaming orations of Savonarola, who committed the vanities of the Florentine patricians to the bonfires, Michelangelo disdained ostentatious pomp and circumstance all his life. Even his own contentment seems to him a worldly

temptation, and sensual pleasures prey upon his conscience: "Though there comes over me, / while I am close to sweetness, a strong, harsh thought / of shame and of death." Asceticism and suffering, by contrast, are morally acceptable. Appropriately enough, one of the roles in which he portrays himself on the Sistine Chapel Ceiling is that of the gloomy biblical figure of the doom-saying prophet Jeremiah (*page* 39).

There are few records of Michelangelo expressing his happiness, let alone feelings of bliss. He seems to have spent much of his life complaining and grumbling about himself and all he did. Yet his lamentations harbour a touch of superstitious pessimism aimed at banishing envy and misfortune by repeatedly naming them. And so, when he rails, he rails mainly at those who are nearest and dearest to him. In his letters to his family, he admonishes and chastises, quibbling about money and bossing them around with caring concern and self-pity. Through the decades, his letters tell of how little he sleeps, how badly he eats, how he has "never enjoyed one hour of happiness … suffering every humiliation and cruelty," how his "body is wracked by effort," how he lives in personal poverty, "in misery and want" – all in order to support his ungrateful relatives who are surely bound to squander everything he gives them. It is also a mark of his deep inner contentment at having put aside every spare *scudo* he earned as a young man. From 1506 onwards he began investing most of the payments he received in real estate, which seemed to him a secure and profitable nest-egg, watched over with care. Michelangelo rather likes to see himself in the role of the firm yet kindly father-figure "who helped many poor people, … and who secretly provided dowries for many young girls," as reported by Vasari.

In his later years, he took an interest in, and magnanimously cared for his extended family, including his assistant Antonio Mini and the orphaned children of his beloved servant Urbino.

"I, Michelangelo Buonarroti" expresses the almost sedately bourgeois and rational core of this artist's complex personality, the pragmatic inner compass that guided him all his life through the stormy maelstroms of art, love and politics. Looking after his family with paternal affection overlaid in the patriarchal tones of businesslike sobriety (*page* 41), he might just as easily have been the satisfied head of a Florentine bank. For all his mutterings, he loved his family, but he loved them first and foremost as a *concetto* – an idea. He avoided their physical proximity, often turning down visits from relatives with excuses about lack of space or the expense of travelling. His letters, especially in the last decades of his life, repeatedly suggest the aloof detachment of a person conscious of his status and commanding respect.

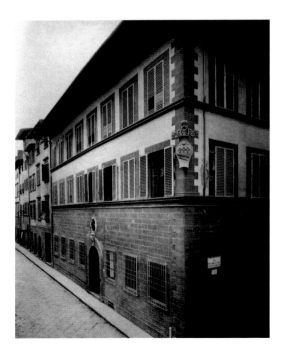

Casa Buonarroti in Florence, puchased by Michelangelo in 1508.

In the company of his peers and close friends, however, we find a very different 'private' Michelangelo – jovial and witty, "neither painter nor sculptor nor architect, but whoever you want; though not a drunkard, as I told you at home" he wrote in a letter to his close acquaintance and co-worker Luigi del Riccio in 1546. Del Riccio had nursed the gravely ill artist back to health in his apartment in the house of Strozzi-Uliveri. Given that Michelangelo attributed his recovery not only to the ministrations of the physician and Riccio, but also expressly to the 'Uliveri wine', it would seem that it had not been all gloom and doom by his sickbed. In the 1530s and 1540s, he felt distinctly at ease in the company of men, among his fellow artists, poets and intellectuals – most of them Florentines in exile – who were as capable of high-flown philosophical discourse as they were of bawdy ribaldry. He enjoyed spending his evenings with them, eating, drinking, carousing and even accepting their invitations to join in the carnival festivities with them, as he did on one occasion with Pietro Antonio: "And so we shall have some fun and no-one need know, and you shall see for a fact what I have often enough described to you in words." Michelangelo cultivated lasting relationships with his closest friends: Sebastiano del Piombio, with whom he worked closely, the Florentine chaplain Giovan Francesco Fattucci, who often negotiated contracts on his behalf, his servant and assistant Urbino, the publisher Donato Gianotti and Luigi del Riccio, who also acted as his secretary and edited his poems.

Michelangelo's correspondence with his close confidant Riccio is brimming with wit and teeming with culinary details, from the huge tench they shared at Lent to the burlesque of their Bracci epitaphs. However sad the occasion may have been, the epitaphs – intended only for an inner circle of fellow poets – were a veritable feast of double entendre and a tribute to the reality of a life in which honourable sentiment is seasoned with the spice of trivia. Cecchin Bracci – a young man celebrated for his grace and beauty – died in early 1544 at the tender age of fifteen. He was Riccio's nephew. Bracci's distraught uncle asked his friend Michelangelo to design a tomb and a portrait bust. Michelangelo, who had also been very close to Bracci, put his assistant Urbino in charge of making the tomb, but consoled Riccio by creating fifty epitaphs, embellished over the years with increasingly ironic subtexts. The pathos of the epitaphs for Bracci "with whose sun the sun of nature was put out forever" is underpinned by Michelangelo's increasingly prosaic commentaries on the poems. Riccio expressed his gratitude for the verses by sending gifts of fine food, and Michelangelo kept on churning out more and more poems "for the salted mushrooms, … for the plump pigeon,

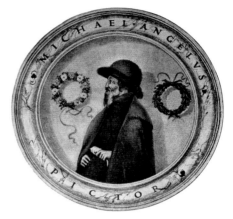

The "bourgeois" Michelangelo in his later years, portrayed in a watercolour by Francisco de Hollanda, *c.* 1540, Escorial, Madrid.

Three menus drawn up by Michelangelo, undated, Archivio Buonarroti, Florence.

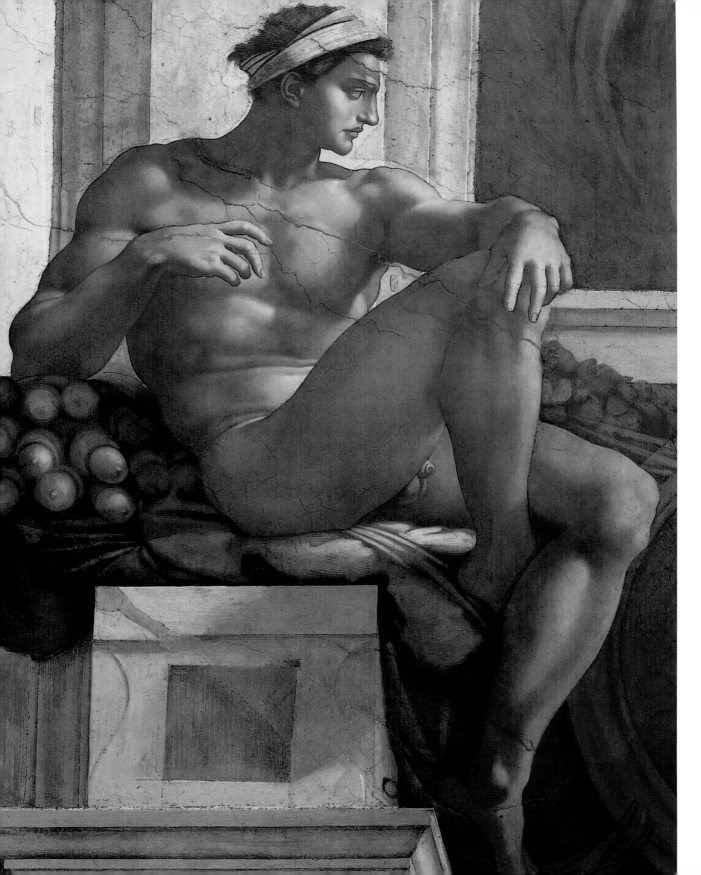

… for the fig bread, … told a thousand times, for the fennel …" and one he sent because "the trout and truffles would force Heaven itself [to write poetry]." For the sixteenth poem, he penned an unofficial variation about the one to whom Cecchin had been 'a joy in bed' and in another he punned on the name Bracci (meaning 'arms') by saying that he might have escaped death better had he been de' Piedi ('feet'). The witticisms continue with him signing one of his letters "Your Michelangelo at Macel de' Corvi" and illustrating his Roman address at the 'slaughterhouse of ravens' with a drawing of a raven.

His whimsical irony is evident in earlier letters to his Florentine friends, which include jokes and drawings, such as a 'self-portrait' of the artist as St Michael, with his initials in the form of a winged angel's head.

The visual puns are by no means restricted to his private correspondence, as can be seen if we take a look at the *ignudi* of the Sistine Chapel Ceiling *(left)*. While the luscious garlands of acorns are an obvious reference to the family name of his patron, Pope Julius II 'della Rovere' ['of the oak'], the unmistakable resemblance between the acorns and the penises of the Ignudi can also be read as saying 'della Rovere is a dickhead' [*testa di cazzo* was a widely used Tuscan insult]. In this way, Michelangelo found a subversive outlet for his pent-up aggression against the Pope who had forced him into this strenuous work. As for the Pope himself, he at least had the magnanimity and the humour – for it surely did not escape his notice – to turn a blind eye to this ambiguous homage.

Detail from a letter written by Michelangelo to Luigi del Riccio with four epitaphs for Cecchino Bracci, 1544. Archivio Buonarroti, Florence.

Humour is not a trait readily associated with an artist hailed as early as 1532 in Ariosto's *Orlando furioso* as a 'divine angel'. Ever since, divinity and tragedy have been part and parcel of the romantic cult of genius. Yet our image of the *angel divino* would not be complete if we were to ignore the diabolically mordant sarcasm of his art and poems, in which the sacred so often goes hand in hand with the language of the gutter and the transcendental is blended with razor-sharp realism. What is crucial is that these elements do not clash or cancel each other out, but complement each other. The duality of Michelangelo's creative universe is rooted in the complex ambiguity of his personality: melancholy and cynical, long-suffering and pragmatic, a stickler for detail and a boundless dreamer, a republican-minded Tuscan *popolano* with upwardly mobile ambitions to enter the aristocracy, a god-fearing ascetic with a taste for sensual pleasure, a man of tender passions and a bristling satyr. Neither side can be properly understood without taking the other into account.

This sour-faced, solitary maverick whose biography was written by his contemporaries Ascanio Condivi and Giorgio Vasari, is only one of Michelangelo's many identities. To Vasari, his reclusiveness and melancholy were fundamental evidence of his artistic genius. In this, Michelangelo paved the way for the myth of the artist as martyr. For example, he lets Condivi relate that he completed the Sistine Chapel Ceiling alone and without any help whatsoever. In fact, he actually had the constant support of a group of

Ignudo with a garland of acorns, detail of the Sistine Chapel Ceiling.

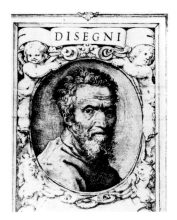

Portrait of Michelangelo. Engraving by
Giorgio Vasari (1511–74).

trusted assistants. For the major Medici projects in Florence, he even headed a team of as many as 300 workers, most of them hand-picked by Michelangelo himself. His youth in Settignano and in the artisanal Santa Croce district of Florence had given him an intimate knowledge of this social stratum, and he gave his assistants nicknames such as 'porcupine' or 'antichrist'. He felt perfectly at home in the earthy atmosphere of comradeship, ribaldry and foul language that prevailed on building sites and in stone quarries, where he himself spent so much of his time over the years. As a sculptor, he was used to living and working in sweaty, grimy conditions: "The marble dust flours him all over so that he looks like a baker; his back is covered with a snowstorm of chips, and his house is made filthy by the flakes and dust of stone" is how the elegant Leonardo, with Michelangelo in mind, described the purely mechanical work of the sculptor – as opposed to the intellectual activity of the well-dressed painter guiding his brush in charming surroundings to the accompaniment of pleasant music.

Other less sharp-tongued witnesses describe Michelangelo as extremely hard-working, living in squalor, unwashed amid the 'incredible filth of his domestic life'. Michelangelo himself sarcastically described his home and workshop in the seedy slaughterhouse district near the Trajan Forum as a 'dark grave', cobwebby and cavernous, where others 'leave cats, rotting flesh, flies and bedpans.'

"I am shut up here, all alone and poor,
 as is the pulp of a fruit by its husk,
 like a genie bound up in a bottle;
 …
 Around my doorway I find gigantic dung-heaps,
 as if nobody who eats grapes, or has taken
 a physic, ever goes anywhere else to shit …"

Michelangelo "often slept in his clothes, wearing the boots he always wore … and never took them off until eventually the skin came off with them as a snake sheds its skin." This anecdote about the boots, which is also included in Vasari's *Vita*, is recorded in the biography that Michelangelo more or less dictated to Condivi. So it would seem that he was not entirely averse to the image of the unkempt artist living only for his craft. In his phases of depression, he takes an almost masochistic pleasure in playing the role of the rugged stone-quarrier from Settignano. In his youth, he had dined at the table of the Medici and in Bologna he had spent months as an honoured guest at the Palazzo Aldrovani, where he would regale his host of an evening with recitals from Dante and Petrarch. It was not until he came to the papal court of Julius II in Rome around 1508 that Michelangelo adopted the pose of the low-life lad in stinking dog-skin boots.

Only shortly before that, Michelangelo had triumphed with his *Pietà* and his *David*, had been hailed as the brilliant young god of Italian art, surpassing even the great Leonardo, and had created his own heroic ideal image in the figure of *David*. The darling of the papal court, he was inundated with contracts and commissioned to design a tomb for the Pope that was to outshine anything that had ever gone before. Now half of St Peter's square was strewn with the hundred tons of marble for the Julian monument he was no longer allowed to build. He felt threatened by the intrigues of the papal architect Bramante, whom he blamed for the postponement. He felt humiliated on a daily basis by the authoritarian brusqueness of the Pope, who treated him like a mere artisan and servant. Added to that was his frustration at having to take on the odious task of painting the Sistine Chapel Ceiling, working in a genre in which he felt ill at ease: "I'm not a painter," he declared in his Sonnet to Giovanni da Pistoia (*page* 27).

It was in the autumn of 1508, just as Michelangelo was reluctantly making his first tentative brushstrokes on the ceiling, that the ambitious young Raphael of Urbino (*right*), a protégé of the Bramante clique who had already vied with him in Florence, appeared on the scene. Rome was enchanted by Raphael's affable personality, youthful good looks and perfectly harmonious painting. It was the meteoric rise of this young Apollo, the handsome Raphael with the charmingly courteous manners and flamboyant lifestyle, to become the Pope's new favourite – and by a hair's breadth a cardinal – that

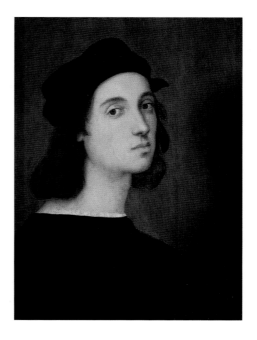

Self-Portrait by Raphael, 1509, oil on wood, 45 x 35 cm, Galleria degli Uffizi, Florence.

triggered Michelangelo's response in cultivating the diametrically opposite image. He countered the velvet-clad gentility of his Umbrian rival by playing the proletarian Tuscan roughneck who did not even shy from cursing the Pope to his face and throwing him out of the Sistine Chapel when he came to inspect the work in progress. Fearing that Raphael, who was working on the *Stanze* nearby, might even steal his ideas, Michelangelo became increasingly reclusive: "I live here in great fear … and without a single friend."

Ironically, it is to none other than the sensitive portraitist Raphael that we owe the most accurate picture of the brusque and introverted Michelangelo. Deeply impressed by the first section of the *Sistine Chapel Ceiling*, unveiled in 1511, Raphael paid his respects to his rival by adding him to the forefront of the group of prominent artists in *The School of Athens* (*page* 46). Painted with the same heavy muscularity as the *Sistine* figures, this pensive loner in his artist's smock and baggy boots is supposed to represent the Greek philosopher Heraclitus. The reference, however, is ambiguous. Is Raphael making some pertinent point about the correspondence between Michelangelo's dialectics and Heraclitus' notion of the inherent harmony of opposites? Or has he portrayed Michelangelo in the guise of the 'dark' philosopher merely because Her-

aclitus, for all his noble origins, was notorious as an unkempt misanthrope? In *Parnassus*, another of his frescoes for the Stanza della Segnatura, the laurel-crowned figure in red looking over his shoulder may also be Michelangelo *(right)*. In this case, there can be no doubt at all as to who is playing first fiddle as Apollo among the Muses on Mount Parnassus.

Though the triumph of the Sistine frescoes heralded a dramatic turn in Raphael's development, he remained the leading artist in the Vatican and in 1514 he succeeded Bramante as chief architect of St Peter's. Leonardo, by now utterly immersed in his fantastic experiments and inventions, spent his time in Rome constructing strange monsters out of air balloons and terrifying visitors with a live lizard to which he had attached horns, a beard and moving wings. In 1516, Leonardo moved to France, where he died in 1519. Michelangelo, meanwhile, continued his work on the Julian monument and spent years in the stone quarries of Carrara and Pietrasanta breaking marble for the facade of San Lorenzo. Raphael was to remain a thorn in Michelangelo's side until his untimely death in 1520. Decades later, Michelangelo was still blaming his misfortune on the envy felt by Raphael and Bramante: "They tried to ruin me; and Raphael had every reason to do so, for all he knew of art, he learned from me." In his old age, Michelangelo had the satisfaction of crowning St Peter's with a cupola of his own design as chief architect of the new building. By 1520 he was the undisputed star of Italian art, with only Titian emerging as a rival of any stature in the field of painting. He stood at the centre of a huge array of projects and enjoyed unprecedented power and authority as an artist. By now, the Popes themselves, the gentle Medici brothers Leo X and Clement VII, who had known him since their youth, were beginning to fear the artist and his impulsive *terribilità*. The painter Sebastiano del Piombo, his representative at the Vatican, told him "You strike fear into everyone, even the Popes." There is a touch of coquettishness in Michelangelo's correspondence with Sebastiano, in which he complains in great detail about being described in Rome as *terribile*. After all, Julius II had been called the *Papa terribile* – and it had been an expression of great awe at his power and boldness.

And so Michelangelo styled himself the *Papa terribile* of art and, with that, its prince absolute. He was no longer the 'sculptor Michelangelo', as he had hitherto signed his letters, but the sovereign demiurge who does not fulfil contracts, but magnanimously dispenses the blessings of his art. In 1548, as chief architect of St Peter's, he even went so far as to expressly forbid that he be addressed any more as *Michelagniolo scultore*: "I have never been a painter or a sculptor like a shop-keeper … although I have served three Popes, having been obliged to do so." He withdrew his favour from those who failed to pay him due respect. Even in 1506, when he left Rome, incensed at not having been admitted to see the Pope, he had exclaimed: "From now on [the Pope] can come to me if he wants anything from me." It was only the threat of a papal war against Florence

Michelangelo as Heraclitus, detail of Raphael's *School of Athens*, 1510, fresco, base length *c.* 770 cm, Stanza della Segnatura, Vatican, Rome.

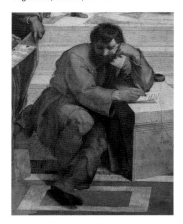

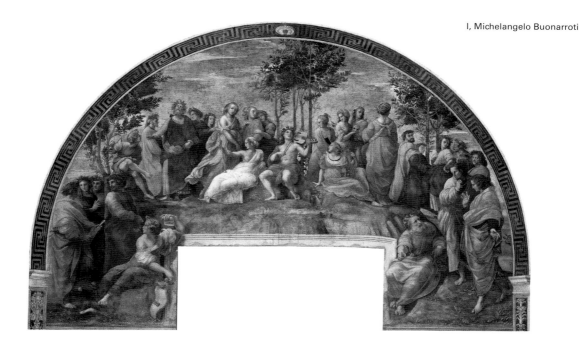

Raphael may also have immortalised Michelangelo in his *Parnassus* (as the laurel-crowned poet in a red robe), 1510–11, fresco, base length *c.* 650 cm, Stanza della Segnatura, Vatican, Rome.

that eventually enabled the *gonfaloniere* Soderini to persuade him to accept a reconciliation.

In 1530, Michelangelo insulted the great military leader and art connoisseur Alfonso d'Este who had always treated him with the utmost respect and admiration and who had been trying for eighteen years to obtain any work whatsoever by his hand. When the artist finally relented, and an emissary was sent to collect the commissioned painting of *Leda and the Swan*, the man in question, a simple dealer, made the mistake of describing the work as 'a mere trifle'. Michelangelo turfed Alfonso's messenger out and gave the painting to his assistant Antonio Mini instead, who later sold it to the King of France. Like the story of the boots, this episode is also included in the biography by Condivi, to which Michelangelo himself contributed so many anecdotes. The vivid contrasts create a tangible overall portrait: the somewhat affectatious descriptions of the shabby poverty in which he lived and his crude behaviour merely serve to heighten the image of the artist who flouts convention, all the while consorting with popes, princes and kings as his equals. During the 1530s and 1540s, his life in Rome was a social whirl. Moving in the highest aristocratic circles and counting among his friends Victoria Colonna and Tommaso Cavalieri, the occasional modish 'doublet of black satin' that found its way into his wardrobe did not find its way into his autobiography.

The Condivi biography begins with a lengthy description of the Buonarroti family's origins in an ancient and noble line going all the way back to the imperial Staufen dynasty. In 1520 Michelangelo received a letter from the Count of Canossa that – incorrectly – implied some family connection. To Michelangelo, this seemed a vindication of his life as a pampered prodigy in the house of the Medici. He had been fifteen years old and an apprentice painter when his obvious talent and his friend Granacci had gained

him entry to the Medici sculpture garden. It was his brilliant classical version of a laughing old faun that had won him the favour of Lorenzo de' Medici who then welcomed him into his own home like a son, providing him with a generous apanage and a peacock-blue coat. There, Michelangelo received instruction from the humanist philosophers and tutors of the Medici household and Lorenzo himself took a keen personal interest in the young man's artistic development. Two years later, following the untimely death of Lorenzo de' Medici, Michelangelo returned to the material and intellectual deprivation of his father's house to become an artisan dependent on the commissions of wealthy patrons – even if it was just the snowman that Lorenzo's arrogant successor Piero ordered from him.

The Medici garden was his Paradise Lost – the place where his own art had brought him almost aristocratic status and the opportunity of pursuing his creative urges unfettered by material constraints. It was to remain his ideal all his life. Working to order for a patron – 'having been obliged to do so' – was a complaint he would often voice. In fact, he enjoyed unparalleled privileges. Unlike many other friends and members of the government, his career had survived the fall of the Florentine republic that had risen up against the Medici, and for which he had served as architect of defences. His status and reputation remained more or less unscathed, with Clement VII pardoning him in order to continue his work on the Medici tombs. At a time when other artists, such as Parmigianino, were still liable to be thrown into gaol for failing to fulfil a contract, Michelangelo, who had left some of his major commissions unfinished since 1501, was a legend in his own lifetime.

The Jeremiah-like lamentations of Michelangelo's letters and many of his poems have forged an image, etched in the collective mind, of an artist suffering heroically for his rebellion against the tyranny of his patrons. In fact, in an age when the dominance of the patron and client was taken for granted, no other artist enjoyed so much creative freedom in his designs and in his choice of materials and subject matter, nor had at his disposal so many resources. At core, the sufferings of Michelangelo had less to do with his subjugation to his autocratic patrons than with the suffering of the individual in the modern world, the divided self, torn by his own soaring ambition and often unattainable goals. He would begin his work on such major projects as the Julian monument or S. Lorenzo by spending months and even years in the stone quarries – 'taming the mountains', as he put it. Not since the days of classical antiquity had marble been quarried in such quantity and on such a monumental scale. The masses of stone that Michelangelo set in motion advanced across the main squares of Rome and Florence like an invading army. The blocks of marble heaped there seemed like a constant admonition. Whatever visions Michelangelo may have had among the inspiring mountain peaks, the everyday reality of the building site with all its hard labour and risk was often disappointing. This is summed up in one of his poems:

"Once hidden and enclosed in a great rock,
I came down, against my will, from a great ravine
in the high mountains to this lower place,
to be revealed within this little stone."

The white blocks of marble beseiged Michelangelo himself, oppressive in their heaviness and hardness, burdening him with the unpredictable problems of transportation and cutting. He may have tamed mountains, and even moved them, but he remained in their thrall. It was to stone that he was bound in servitude – and to time itself, which posed the greatest threat of all to his grand visions:

"Alas, alas, for I have been betrayed
by my fleeting days and by the mirror
that speaks the truth to all who look hard at it!
That's what happens when one delays too long at the end,
as I have done, while time has fled from me:
he finds himself in one day, as I have, old.
And I can neither repent, nor prepare myself,
nor ask for guidance, with death so near to me.
Enemy of myself,
in vain do I pour out my sighs and tears,
for there's no hurt that's equal to time lost."

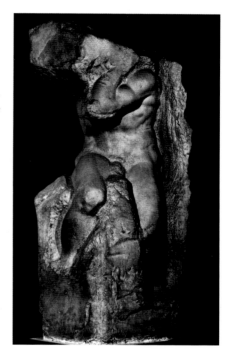

The figure of the *Atlas Slave*, 1525–30, also represents Michelangelo's struggle with the stone.

Already more than fifty years old, Michelangelo had, by the standards of his era, crossed the threshold to old age. His favourite brother had died in 1528 and any time lost or wasted now became an increasing torment to him. He would work late into the night, by the light of tallow candles mounted on a paper cap. However, since the *Sistine Chapel Ceiling* more than a decade and a half previously, he had not actually completed any single work. The unfinished Julian monument still lay in Rome, the Medici works still awaited him in Florence. Everything was gridlocked by the political confusion of the Sack of Rome and the Florentine Republic. In the state of uncertainty that prevailed in the late 1520s and early 1530s, Michelangelo turned increasingly to poetry as an outlet for his emotions. The few sonnets and madrigals of his early years had, for the most part, addressed some undefined object of desire. Some were poetic exercises in the style of Dante and Petrarch, others acerbically mocking ditties written to give vent to his frustrations. Now his poetry began to take on a more personal contour and increasingly became an expression of his inner self. Michelangelo would jot down his verses and drafts while he was working, scribbling them on sketches, letters and invoices. It was

only later, in his Roman period between 1532 and the death of Riccio in 1546, that they took on the status of official artistic testimonies transcribed by Michelangelo and his friends and reworked with a view to publication.

In their original form, however, many of Michelangelo's poems are not so much the linguistic expression of his boundless creativity, but an evocation of creative turmoil, an impassioned and sometimes self-effacingly sarcastic plea against the menacing sense of emptiness within. Most of the poems are autobiographical, and many are highly self-critical. Yet, as in the Bracci epitaphs, there is another aspect to be borne in mind. Michelangelo uses the medium consciously, writing in the typical post-Petrarchan style of the *lamentio*. There is something liberating and exhilarating about the celebration of pain and suffering. Like mordant caricature, exaltation and pathos are also literary devices – as opposed to a diary merely detailing the writer's current state of mind. There is also an element of self-adulation in the torment and constant self-abasement. The love poems are more about desire itself than about the object of that desire. Yearning is not aimed at fulfilment but at heightening a state of emotion. For all their emotional profundity, it is of little relevance whether the beautiful eyes that have sparked the flame of desire are those of Gherardo Perini, Febo di Poggio, Tommaso Cavalieri or Vittoria Colonna. What is more, Michelangelo would often rework the same poem, simply substituting a different salutation. It is the flame itself and not the spark that lit it, that is the focus of his love poetry. In times of crisis and creative ebb, this devotion to the burning fire of love brings a source of new inspiration.

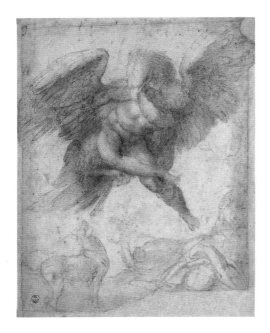

The Rape of Ganymede, c. 1532,
red chalk, 31 x 22.5 cm,
Galleria degli Uffizi, Florence.

"I live on my death and, if I see rightly,
I live happily on my unhappy fate;
one who doesn't know how to live on death and anguish
should enter the fire where I'm burned and destroyed."

The object of desire is heightened as the personification of Eros, who, according to Neo-platonic thinking, is the transformatory force that elevates the earthly suffering of the soul to the level of divine celestial beauty. In this way, Michelangelo creates an externalised element embodied by beauty that makes him a slave to love while at the same time inspiring his art and guiding his hammer.

Detail of the *Dying Slave*, 1513.

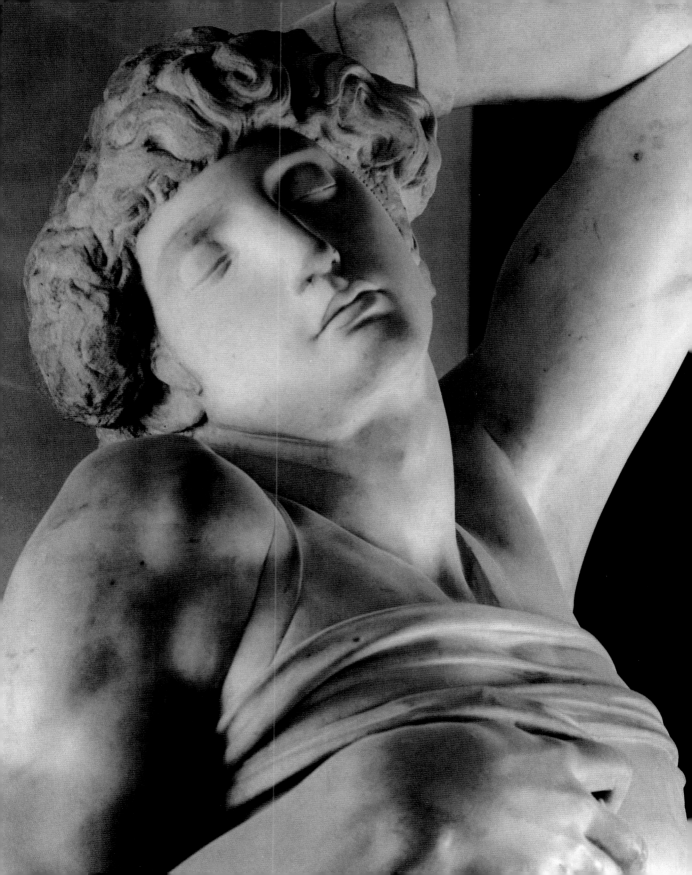

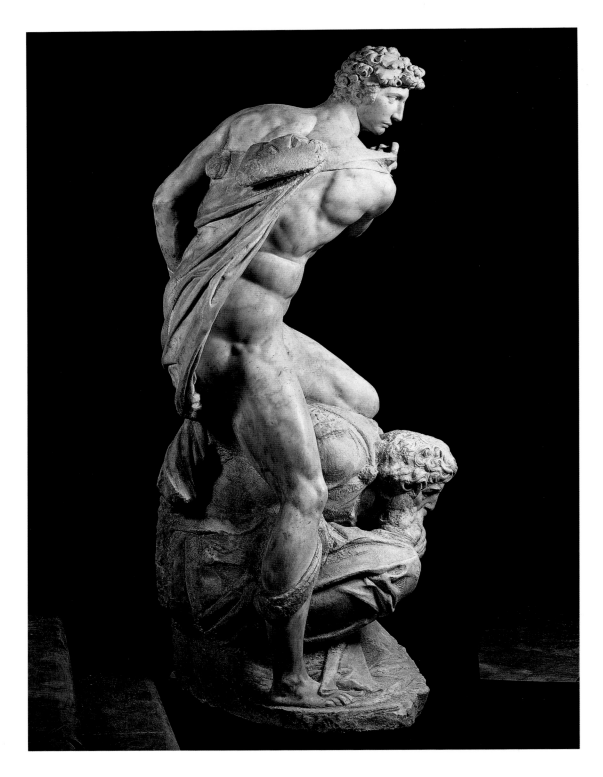

In 1524, in the early years of his poetry, Michelangelo felt love "draw new leaves and flowers from a dry tree." Like a fire, "It warms the chilled old man, then nourishes him, / Propels him back so close to his green years, / Renews and kindles, cheers and rejuvenates him, / That love's breath twines around his heart and soul" for, as he writes, "… one who does not fall in love / with those fair eyes can't live." Yet a note of warning soon creeps into his poems: "Flee, lovers, from Love, flee from his fire; / Its flame is cruel and its wound is deadly." What follows is a sense of profound regret: "My life no longer belongs to me, but to sin." In Neoplatonic thinking, beauty and love in their worldly, sensual form are above all an image – the earthly appearance of the divine from which they come and to which they seek to return: "Love – nay, burn; for one who's mortal / has no other wings on earth for going to heaven." Michelangelo's poetry is informed by the dichotomy between sensual and heavenly love:

"I recognize my danger, and know the truth;
Yet on my other side dwells another heart
That slays me more the more I yield to it.
My lord is thus poised in between two deaths:
One I don't want, the other I don't understand;
Left hanging like this, both soul and body are dying."

The triumph of youth over age in *The Victory* (detail above and full view opposite), *c.* 1530–33.

From 1532 onwards, this conflict undergoes a gradual transformation, with the fire metamorphosing from an all-devouring force into a predominantly fertile one. "Having a heart of sulphur, and flesh of aokum, / and having bones that are made of dried wood; / having a soul with no guide and no reign, / quick to respond to desire and extreme beauty." writes Michelangelo, feeling he will burn in "a flash of fire" for the young Roman nobleman Tommaso de' Cavalieri, who now takes on the role of the inspiring sun or the sun god Phoebus Apollo. At the same time, this place is also occupied on occasion by another "Phoebus", the young Febo di Poggio, whose "feathers were my wings to me, his hill my steps … to Heaven." This was a love that was more in the realms of earthly desire: when Febo is described as "burning all the hill", this could well be a reference to his burning a hole in Michelangelo's bank account, which the artist often referred to as the "hill" [Monte della Fede being the name of his Florentine bank]. While the somewhat unsalubrious Febo wheedled money out of the artist, the 23-year-old Cavalieri, renowned for his erudition and beauty, was Michelangelo's aristocratic ideal.

His great love for Cavalieri, which probably also played a role in Michelangelo's decision to move to Rome permanently in 1534, gave him a new lease of life. With Cavalieri in his heart, Michelangelo felt ennobled, his self-esteem restored, and "dearer to myself than was my wont". In the sonnets, Cavalieri is the personification of Day, the Sun,

whose burning has a purifying and transformatory effect, like that of the phoenix. Michelangelo, on the other hand, identifies himself with gloomy, but creative and fertile Night: "Man can be planted only in the shade. / Therefore the nights are holier than the days …." The association of love and subjugation, pain and death, already propagated at the court of the Medici by Marsilio Ficino, is in evidence here (*pages* 52/53):

"If, to be happy, I must be conquered and chained,
it is no wonder that, naked and alone,
an armed cavalier's prisoner I remain."

The insoluble conflict between the young, unfeeling object of his love and the unworthy humiliated old man is not the barrier to happiness but its very essence.

"Merciful to others and merciless only to itself,
a lowly creature's born, who with pain and sorrow
clothes another's hand and strips off its own skin,
and only through death might be called truly born.
I wish it were my own fate thus to clothe
my lord's living body with my dead hide,
so that, as a snake sheds its skin on a rock,
likewise through death could I change my condition.
Oh, if only the furry pelt were mine
which, with its woven hair, makes such a robe
that has the luck to bind so fair a breast,
So I'd have him in the daytime; or the slippers
that make themselves a base and support for him,
so I might carry him for at least two snows."

The addressee of this unofficial sonnet – never delivered, or even transcribed from its draft form – is presumably Tommaso Cavalieri. It contains many of the frequent themes of age difference and social status, of subjugation and unquenchable desire; the writer portrays himself as a lowly, ugly, old animal in comparison to the beautiful young well-born gentleman. The longed-for unity, the desire "to clothe" the other, is possible only by shedding his own skin, by giving himself up completely.

And what a glorious giving-up of self: in 1535, when this poem was written, Michelangelo was designing the fresco of the *Last Judgment* for the altar wall of the Sistine Chapel (*page* 55). He changed his original plan, conventionally portraying Christ enthroned with the Archangel Michael weighing the souls beneath, and replaced the latter with a rather unusual self-portrait. The central constellation is now the

The flayed skin of the martyr Bartholomew bears Michelangelo's own traits. Detail of the *Last Judgment* in the Sistine Chapel.

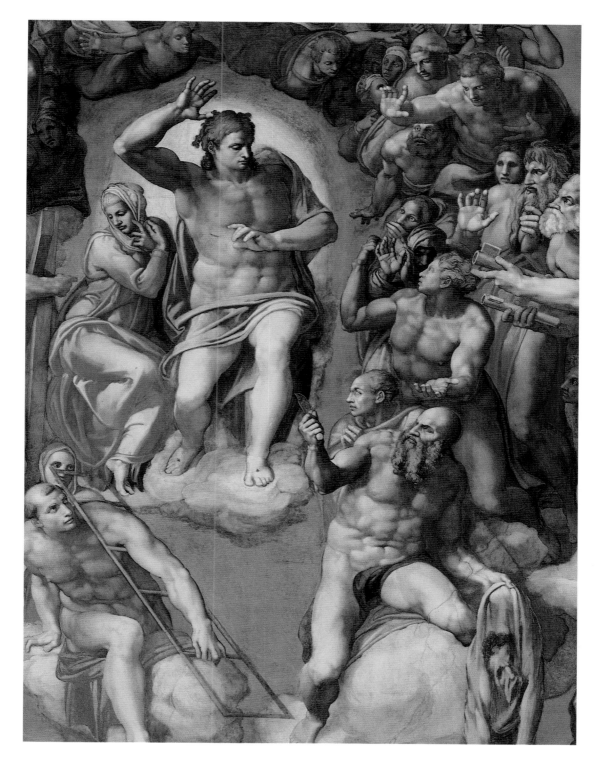

highly charged relationship between Christ of Apollonian stature and St Bartholomew showing the symbols of his martyrdom. The flayed skin bears the traits of Michelangelo – but Bartholomew is also the artist himself. In his hand, instead of the usual knife, he is holding a sculptor's file, and is presenting it with an almost challenging gesture to the figure of Christ / Apollo who has raised his hand in a gesture of benediction or rejection.

Michelangelo is a master of shedding skin. In his youth, he dissected many bodies as part of his anatomical studies. Later, too, skin is a frequent metaphor: from the snake-skin analogy of peeling off his boots to the poems with their many references to skinning, shedding, peeling bark, removing a hard shell; *scorza* and *scorzare* [peeling] are frequent terms in his sonnets. This peeling or skinning is a painful sacrifice as well as a creative act that leads the way to new life.

"From what sharp, biting file
does your tired skin keep growing thin and failing,
O ailing soul? When will time release you from it?"

There is another theme underlying these images – the Flaying of Marsyas. Convinced of the excellence of his flute-playing, Marsyas the satyr, a 'base animal', challenged the god Apollo to a musical competition. He played for all he was worth, but the muses declared the gentle lyre-playing of Apollo to be finer. Apollo then punished Marsyas for his hubris by having him flayed alive. In other words, the satyr Marsyas was punished for measuring himself as an artist with the gods – *divino*. By killing himself as Bartholomew with the instrument of his art, Michelangelo anticipates his own damnation. Yet he also redeems himself, re-creates himself and thereby doubles the provocation of the sovereign creative act in the eyes of Christ / Apollo. For, like Christ, he is legitimised by his own self-sacrifice. The creative artist humbles himself before the divine Creator and challenges Him at the same time – the apotheosis of Marsyas in the place of Archangel Michael on the altar wall of the Sistine Chapel is a bold statement indeed.

Yet what might appear at first to be a gesture of arrogance is merely the monumental transposition of the artist's own radical and lifelong self-scrutiny. With his anatomical self-flaying in the universal context of the *Last Judgment*, Michelangelo once more orchestrates a dialectical choreography of hubris and humility, Apollonian beauty and satyric ugliness, pleasure and punishment, god-fearing piety and diabolical challenge, the sublime and the ridiculous, pious ecstasy and sarcastic wit. Though he goes to the very limits of heresy, he does not go beyond the pale as long as all the opposites are merely the outermost point of a universal order created by the divine Almighty.

With the unveiling of the *Last Judgment* at the end of 1541, Michelangelo walked a very fine line between medieval Christian notions of piety and the predominantly individualistic classical image of humanity. Under the influence of his pious muse Vittoria Colonna and the Counterreformation, he spent the last two decades of his life struggling to replace the complex Neoplatonic view of divinity with a simpler and more direct faith. Ill health and increasing isolation following the death of his closest friends, Riccio, Colonna and Urbino, exacerbated his feeling of world-weariness, and he began addressing more and more of his love poems to Christ. *Signor mie caro* – whereas previous poems had addressed a worldly beauty as the manifestation of the divine, his yearning was now directed towards unity with Christ. Even art, previously a divine instrument, had now becomes a vain obsession, albeit one he continued to pursue with passion.

> "So now I recognize how laden with error
> was the affectionate fantasy
> that made art an idol and sovereign to me,
> …
> Neither painting nor sculpture will be able any longer
> to calm my soul, now turned toward that divine love
> that opened his arms on the cross to take us in."

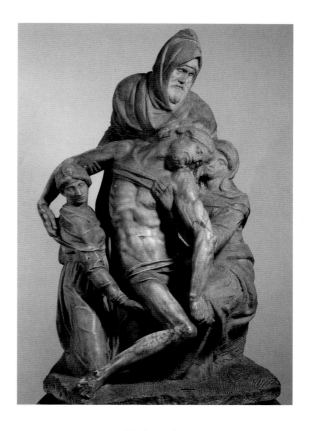

The figure of Nicodemus in the *Florentine Pietà* is Michelangelo's last self-portrait. He had intended this group to grace his own tomb.

Crucifixions and pietàs are the dominant themes of his later years. The sculptor Michelangelo sought in vain to return to the elemental harmony and intimacy of his first pietà. He had tamed mountains, vanquished classical antiquity, challenged the very gods themselves, created worlds of contradiction. Yet disentangling this complexity and devoting himself to the immediacy and piety of Counterreformation Christian spirituality was to prove his greatest challenge of all. In architecture, he created a metaphor of all-embracing unity with his vast dome for St Peter's, but the sheer physicality of his sculpture defies the transcendence of a non-symbolic art geared towards the subjective experience of the Christian mystery. The pietà intended for his own tomb *(page 58)*, in which he gave Nicodemus his own facial traits, was destroyed by Michelangelo in desperation and fury at a perceived mistake he had made.

"In such slavery, and with so much boredom,
and with false conceptions and great peril
to my soul, to be here sculpting divine things."

Right up until just a few days before his death, Michelangelo struggled to lend expression to the merging of the soul with the Lord that he had evoked in his religious poems. For almost a decade, he chiselled ever deeper into the stone, yet beyond the human body that was his creative universe, he could find neither form nor answer.

"The soul gains more, the more it loses the world,
and art and death do not go well together."

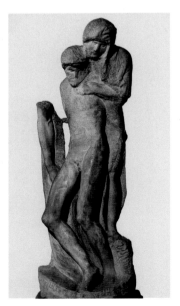

Michelangelo's last sculpture, the so-called *Rondanini Pietà*, on which he was still working just a few days before his death.

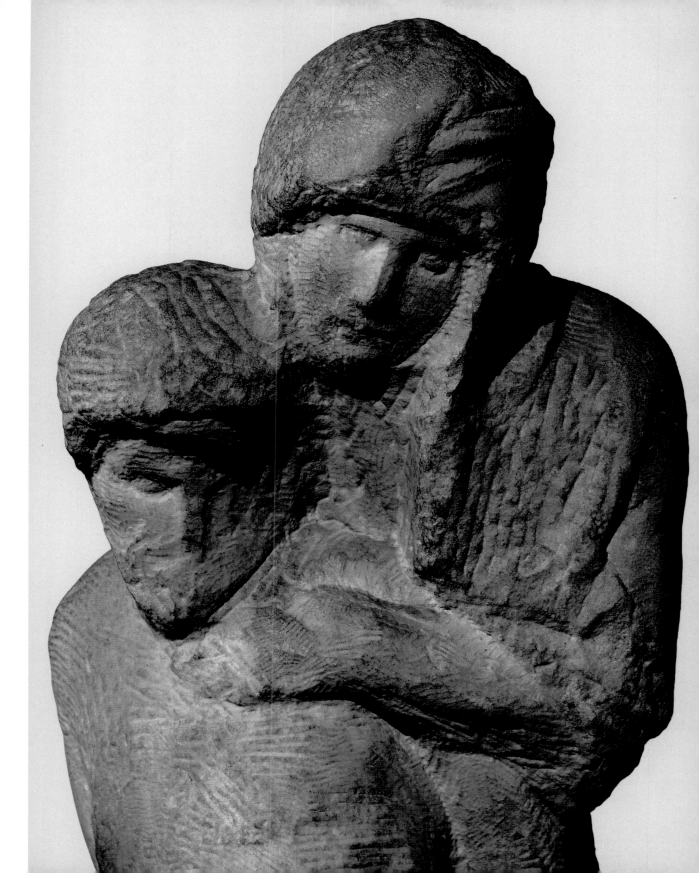

The Art of Taking Away –
The Sculptor and his Stone

"By sculpture I mean what happens by taking away; what happens by adding something is like painting. As long as both of them are based on the same understanding, they can be at peace with one another and all dispute can be set aside, for in dispute more time is lost than in making the figures."

A laughing old faun, based on a classical work in the Medici collection, was the first known sculpture by the hand of the artist Michelangelo, who originally trained as a painter. It was this faun that drew Lorenzo de' Medici's attention to the fifteen-year-old apprentice in his sculpture garden, though he tempered his praise by pointing out that old folk never have all their teeth. According to Vasari, "as soon as Lorenzo had gone he broke one of the faun's teeth and dug into the gum so that it looked as if the tooth had fallen out." Michelangelo himself, in his old age, still described sculpture as "the art of taking away [*levare*]" as opposed to painting, which he saw as additive.

Michelangelo's brilliant early work brought him a privileged position as the favourite protégé of Lorenzo il Magnifico. He was accepted into the circle of the family, among poets and philosophers, and received instruction from the humanist scholar Angelo Poliziano. His training in the art school of the garden of S. Marco was in the hands of the sculptor Bertoldo di Giovanni, himself a student of that great master of the early Italian Renaissance, Donatello. Michelangelo's own sculptural style was thus initially influenced as much by the Renaissance work of Donatello as it was by the classical originals in the Medici garden. The Medici collection included Donatello's *Madonna del Pugliese-Dudley* (c. 1440, *page 62*). This was probably the direct inspiration for Michelangelo's earliest still extant sculpture, the *Madonna of the Steps* (1490–91, *page 63*) which, though entirely in the tradition of the Florentine bas-relief, has a distinctive lyrical undertone. Right from the start, the characteristic style of Michelangelo is evident in the robust muscularity of the figures. Unlike the frail infant in the Donatello version, Michelangelo's Christ child turns inwards with a twist of the arm to bury its

Michelangelo's precocious talent impressed even Neoclassical artists: Emilio Zocchi, *Michelangelo Sculpting the Head of a Faun*, 1861, marble, 60 cm high, Galleria d'Arte Moderna, Florence.

Detail of the *Pietà*, 1499
(full view page 65).

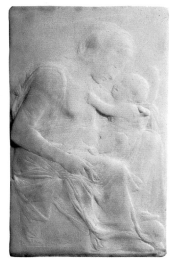

Donatello, *Madonna del Pugliese-Dudley,*
c. 1440, marble, 27.2 x 16.5, Victoria &
Albert Museum, London.

face in the breast of the *Madonna of the Steps*. We find much the same figure repeated, this time as a wrestler, in *The Battle of the Centaurs* which he started soon afterwards (1490–92, *pages* 4 *and* 130).

The Battle of the Centaurs is also rooted in the tradition of classical sarcophagus reliefs and in the battle scenes of the school of Donatello. However, as with his head of a faun and his *Madonna of the Steps*, the young Michelangelo has his own distinctive take on these precursors, lending them realistic elements that imbue them with an almost tangible physical presence and vitality. This self-assured break with tradition at such an early stage is due not only to the undisputed originality of his prodigious talent, but also to the intellectual climate of the Medici court. Instead of being a mere apprentice carrying out instructions in a workshop, Michelangelo found his skills nurtured by scholarly teachers, including, quite possibly, Lorenzo himself. He was set specific tasks that were as inspiring as they were challenging. Indeed, the highly unusual theme of the battle between the Centaurs and Lapiths, drawn from Ovid's *Metamorphoses*, was proposed by his mentor Poliziano. Even the new technique of relief so typical of Michelangelo owed much to Poliziano's literary inspiration.

In the *Battle of the Centaurs* the traditional Florentine bas-relief is developed into a crescendo of plasticity in which the sculptor, instead of deepening the relief, actually draws it forward so that the figures seem to be emerging out of a wall of mist. Aptly, it seems, for according to mythology, as Renaissance commentaries – including Poliziano's own – repeatedly point out, the Centaurs originated in a cloud. This finds visual expression in Michelangelo's work. The organic development of the figures out of the stone is a key aspect of Michelangelo's approach to art, based on the Neoplatonic notion of the *concetto*: the artist chisels the idea out of the stone, rather than imposing his own preformed idea on the material by chiselling it into the stone. In other words, the *concetto* is already present in the material. It is up to the sculptor to reveal the soul imprisoned within the stone, gradually, *per via de levare* – by the subtractive act of taking away. Michelangelo does not create his figures by organically constructing them from within, but by peeling away the outer 'earthly' shell. Throughout his life, Michelangelo regarded himself first and foremost as a sculptor, and saw painting as a secondary art. To him, "painting appears more noble the closer it comes to relief, and relief less noble the closer it comes to painting." He describes sculpture as the guiding 'lamp of painting', but his own personal development, ironically, evolved in exactly the opposite direction, from the painterly to the increasingly sculptural relief (*relievo*) and through taking away (*levare*) to sculpture in the round.

From the moment he made his head of a faun, Michelangelo was constantly grappling with the models of classical antiquity, honing his skills in emulation to the point of counterfeit. Eventually, he even adopted the scale of classical antiquity: in the over-life-size statue of *Hercules* he made while he was still in Florence, in his *Bacchus* of 1497 and

Michelangelo's *Madonna of the Steps*,
1409–91, still clearly shows the influence
of Donatello and the Florentine bas-relief
tradition.

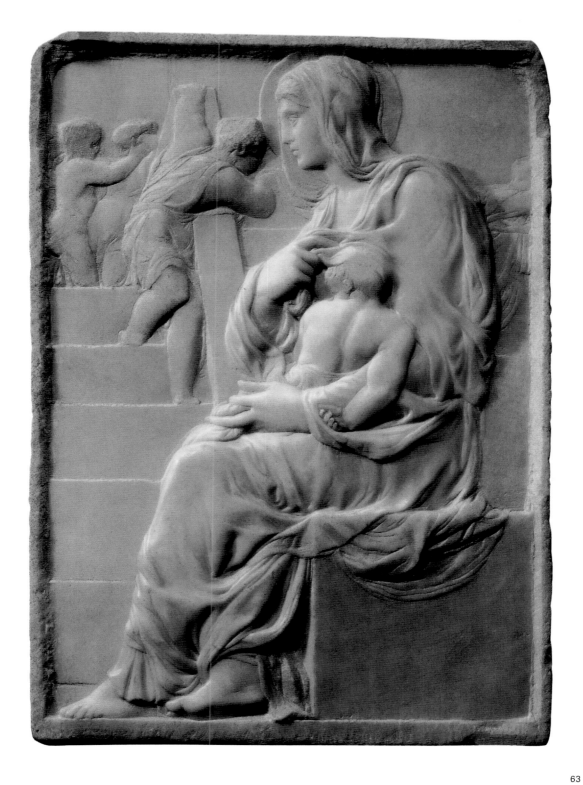

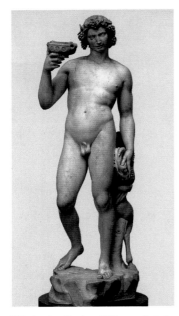

This drunken *Bacchus*, 1497, was rejected by Michelangelo's patron.

Michelangelo's life-size *Pietà*, 1500, carved from a single block of marble, marks the apex of High Renaissance sculpture.

later in his gigantic *David*, the most monumental statue in the round since the days of the Roman Empire. Yet for Michelangelo, classical antiquity was not so much an ideal to aspire to, as a sparring partner to challenge, be inspired by and eventually surpass. Above all, it provided his predominant theme – the nude male body, which he portrayed with his own distinctive realism and sentiment. Michelangelo's figure of a drunken *Bacchus*, tottering unsteadily out of the classical contraposto, was a little too viscerally realistic for the liking of his patron Cardinal Riario, a connoisseur of classical antiquity, which is why he refused to accept the statue he had commissioned *(left)*. The affair of his deliberate forging of a "classical" *Sleeping Cupid* led to Michelangelo being invited to Rome for the first time in 1496. But it was here, of all places, in the very cradle of classical art, that he was to taste failure. After the rejection of his provocative *Bacchus,* he eked his living as a painter until he created a work that would seal his artistic identity and bring him widespread recognition: a work rooted not in classical antiquity but in the medieval tradition of Germany and France.

The tradition of the pietà as an art form can be traced back to the northern European *Vesperbild*, whose naturalistic appearance was intended to appeal directly to the emotions of the spectator. In Italy, too, there are examples of the Lamentation over the Body of the Dead Christ, but these were actually introduced by the French patron Cardinal Bilhères de Lagraulas, who specified this theme for his funerary chapel in St Peter's. Whereas northern European examples of this type tended for the most part to be small and intimate devotional images, Michelangelo portrayed the scene on a monumental life-size scale. Even the contract states that he will deliver "the most beautiful work in marble to be found in Rome today." Ambitiously undertaking to sculpt the group from a single block of marble, Michelangelo took great pains to select the stone personally in Carrara in order to avoid repeating the ignominy of finding the face of his *Bacchus* marred by a vein in the marble. The quarrying and transportation alone took no less than nine months. The block for the sculpture being broad and relatively flat, it is the plasticity of the drapery folds that lend it an appearance of depth. The back of the sculpture is roughly modelled, for it was probably intended to be installed against the right-hand wall of a chapel. The main view, then, would not have been directly frontal, but slightly from the right, and this is underlined by the gesture of the Virgin whose open palm guides the gaze of the approaching spectator towards the body of Christ.

The *Pietà* completed around 1500 is the culmination of what Michelangelo had developed or acquired more than twelve years previously: the observation of nature, the anatomical exploration of the human body, the classical ideal of beauty, the self-contained triangular composition of Leonardo. Even the expressive drapery that reflects the feelings of the figures is influenced by him and by the northern tradition. The figures themselves, immersed in grief but not frozen in pain, exude an air of complete relaxation. They show no inner tension, no exaggerated emotion. Neither too much, nor too

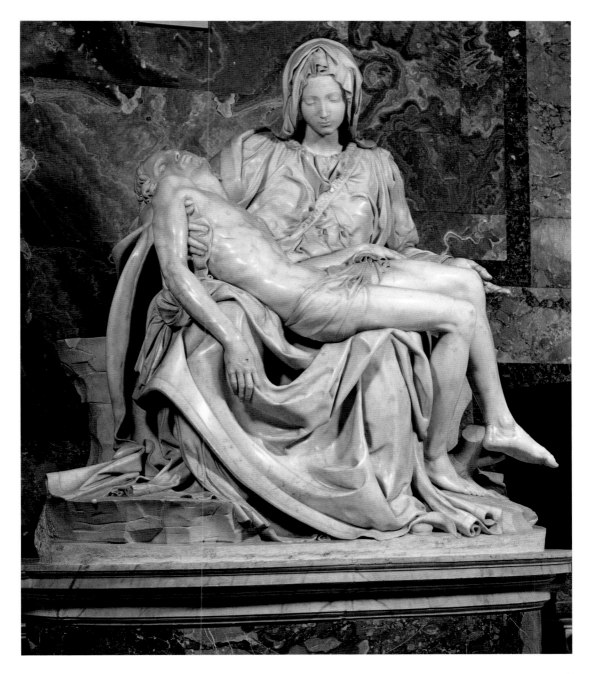

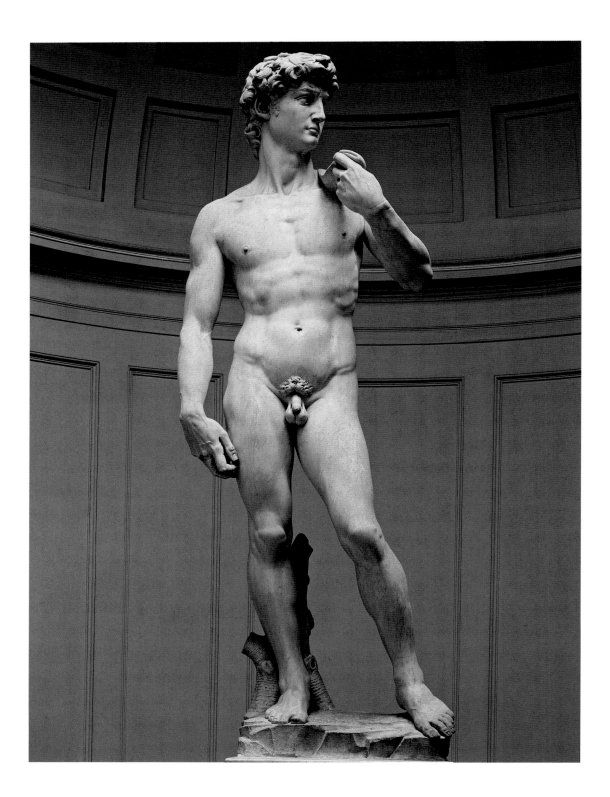

little, is portrayed. What we see here is a profoundly contemplative moment of inner absorption, of perfect harmony couched in a balance of sensuality, form and feeling that marks the very zenith of High Renaissance sculpture (*page* 65).

Michelangelo celebrated this moment of undisputed virtuosity by making the extremely unusual and self-assured gesture of carving his own signature right across the breast of the Virgin: MIHEL.A[N]GELUS.BUONAROTUS.FLOREN.FACIEBA [Michelangelo Buonarroti of Florence made this]. It was the only time he ever did so. The last letter, 'T' – strictly speaking, it should read 'faciebat' – makes an interesting point. According to Pliny, the fathers of classical painting and sculpture, Apelles and Polyclitus, signed their works with the imperfect form 'faciebat' rather than 'fecit' to indicate in all modesty that the work was still in progress in the sense that, although the works themselves were technically completed, they could not be regarded as artistically perfect, for this might be taken as an act of hubris. Michelangelo, who very probably knew of this from Poliziano, was the first Renaissance artist to use the term himself. Indeed, he even heightened the effect with some irony by further underlining the 'imperfect' or 'unfinished' nature of the work in leaving out the last letter of the word. By adding his signature in this way, the 25-year-old artist placed himself on a par with the greatest artists of antiquity.

By inferring that, of all works, this so technically perfect *Pietà* is a work in progress, Michelangelo is actually playing up his skills as an artist. From 1500 onwards, he enjoyed years of uninterrupted confidence in his own ability. The notion of the *non finito* soon became a central tenet in many other areas of his life. Michelangelo's fame became so great that he was drawn into an ever widening spiral of contracts he could barely cope with, even with a huge workshop behind him. He left a half-finished altar-piece behind in Rome when he entered a contract in 1501 to make fifteen marble figures for the Piccolomini Altar in Siena; one clause in the contract required that he should not take on any further work before its completion. Just two months later, Michelangelo signed the contract for the *David* in Florence and put the Siena project on hold. While he was working on the *David*, he undertook to provide twelve statues of apostles for the Duomo, of which he only actually half-completed the figure of *St Matthew* – the first of many 'Captives' that remained imprisoned in the stone. When he was called to Rome by the Pope, he interrupted his work on the *Battle of Cascina* fresco. Nevertheless, Michelangelo carried out several small contracts in Florence for the Republic and for private patrons. In later years, he would rarely accept such commissions.

The most outstanding figure of this period, however, was the 'Giant': the huge block of marble that had been languishing in the workshop of the Operai del Duomo in Florence ever since Agostino di Duccio had roughed it out for the monumental figure of a prophet in 1466, and then spoilt it completely.

One of the sources of inspiration for Michelangelo's *David* was the *Belvedere Apollo*, marble, 224 cm high, Museo Pio-Clementino, The Vatican.

The sculptor's ideal image was also a heroic personification of the republican virtues of Florence: *David*, 1501–04.

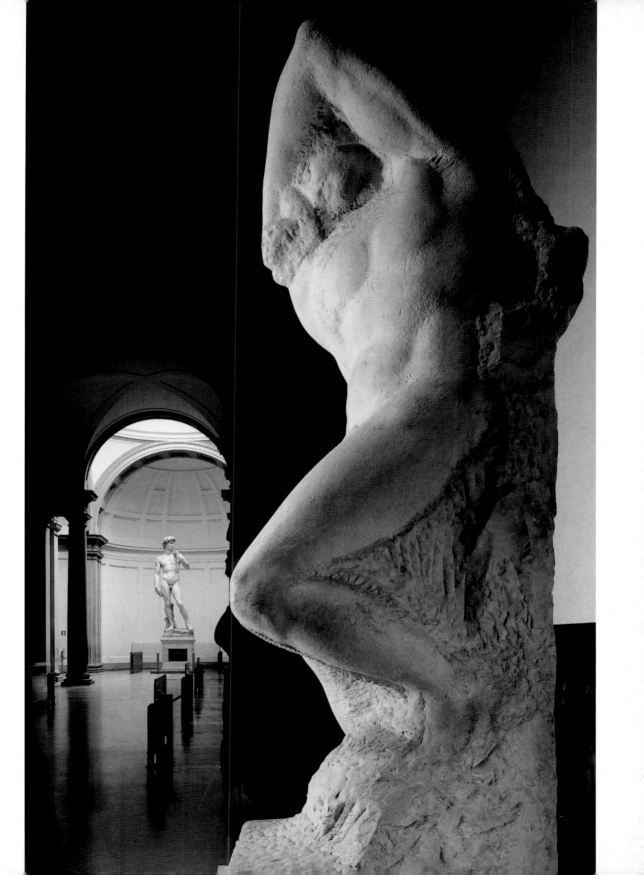

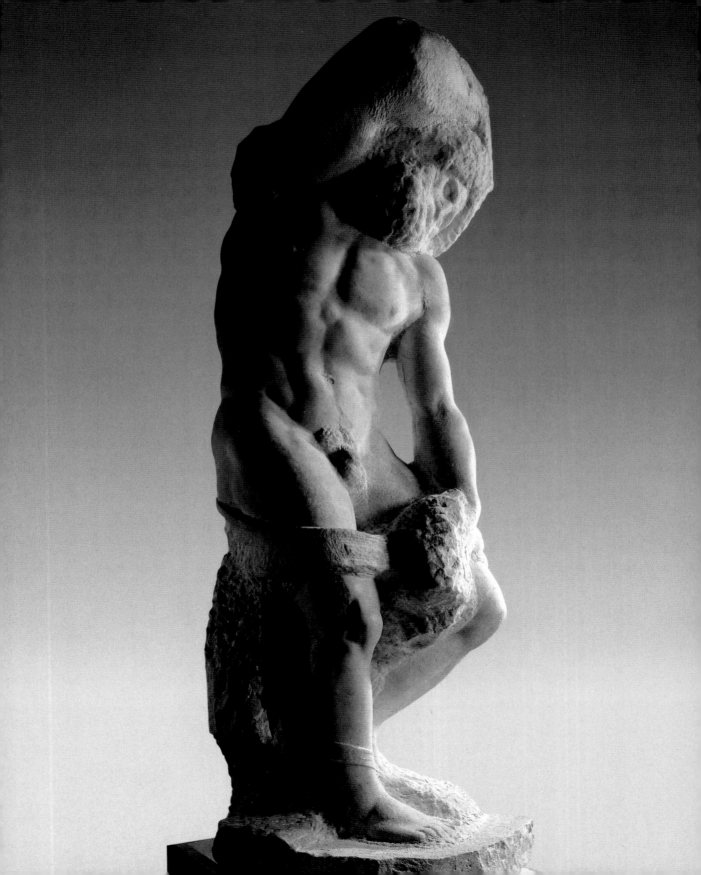

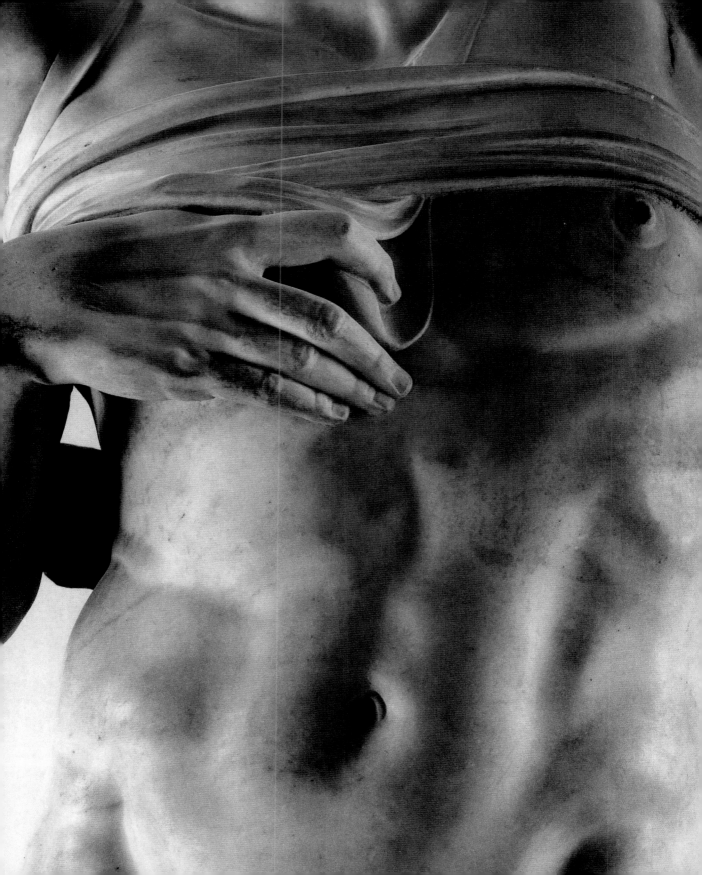

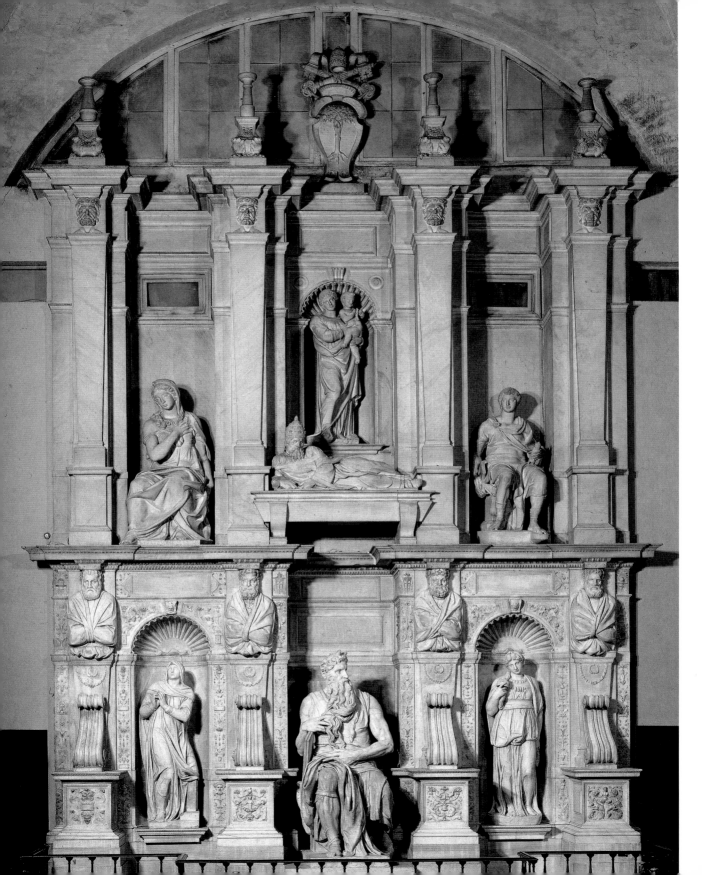

Michelangelo had heard of this already almost mythical block, which had originally been intended as a marble successor to Donatello's colossal white-painted terracotta figure of *Joshua*. When the cathedral board of works decided to commission the *David* anew, they had in mind, among others, Leonardo da Vinci. But Michelangelo, the young rising star of the Florence art world, managed to secure the contract, even though it meant breaking the terms of his agreement in Siena. He achieved what Duccio had so ambitiously attempted in vain: a gigantic statue carved from a single block of marble. He even left a *facieba* in the form of a roughed-out area near the parting of the hair, to show that the entire marble block had indeed been fully used. His contemporaries were astonished by this incredible display of virtuosity. It was the first colossal statue of more than four metres in height to have been created since the Late Roman horse-tamers at the Quirinal, erroneously attributed to the legendary Polyclitus, which had been Michelangelo's benchmark.

Ambition, boldness, stature and confidence are the qualities reflected in the figure of *David*. Michelangelo adapted the smooth and youthful beauty of the Belvedere Apollo to the tastes and lifestyle of his own era by lending him something of the cocky appeal of the *ragazzi* who hang out on the piazza: the coolly relaxed stance, with one leg a little to the side and only the slightly tensed buttocks indicating any sign of nervousness, the sling thrown casually over his shoulder, the right hand almost playfully weighing the stone, the nostrils slightly flared – surely that gaze alone is all it will take to fell Goliath now. Yet even in the Renaissance, a stark naked athlete, no matter how divinely beautiful, was considered inappropriate for the portrayal of an Old Testament character of such importance destined to grace the cathedral as a buttress figure. Apart from the almost insurmountable technical difficulty of actually installing the statue in its intended place, it would have been rather a pity to put it so far out of view. And so, even before its completion, it passed into the hands of the municipal authorities and, after months of public debate, was unveiled in September 1504 at the entrance to the Palazzo della Signoria as a symbol of the Republic. In 1527, during the uprising against the Medici, rioters snapped off one of the arms. From 1543 onwards, in the course of the Medici restoration, the arm was repaired – and the offending genitalia were covered by a metal fig-leaf. Over the decades, the symbol of the rebellious republican spirit had been tamed: it was now a mere ornament embellishing the door of the House of Medici.

This magnificent figure of a young man was originally intended as the heroic personification of the republican virtues of the city of Florence – the 'new Athens' – and, of course, as the ideal image of the artist himself at the height of his heroic creativity. In short, classical antiquity had finally been laid to rest.

Contemporaries such as Vasari felt that "without any doubt this figure has put in the shade every other statue, ancient or modern, Greek or Roman." *David* has absorbed the giant, transforming him and taking his place. He personifies the proud declaration "I,

Reconstruction of Michelangelo's 1505 design for the Tomb of Julius II after Giulio Carlo Argan.

page 68
Detail of *David*, 1501–05.

page 69
Michelangelo's *David* on display near the *Young Slave*, 1540–33, at the Accademia delle Belle Arti, Florence.

page 70
Bearded Slave, 1530–33, Accademia delle Belle Arti, Florence.

page 71
Detail of the *Dying Slave*, 1513–16, Musée du Louvre, Paris

page 72
Full view of the *Tomb of Julius II* in S. Pietro in Vincoli, Rome. After several design revisions, it was eventually completed in 1545 with the aid of several student assistants.

Michelangelo." On a sketch showing the arm of the marble *David* and a design for a bronze *David* commissioned for the republic, the artist has written "David with the sling and I with the bow, Michelangelo" (*page* 134). He is referring to the bow of the drill and compass that are the weapons of the sculptor. He places them at the service of his home city of Florence and in doing so he slays the old Goliath – be it the enemy of the republic or Ancient Rome.

Michelangelo made his way to Rome in the spring of 1505 on a wave of elation. He went at the request of Pope Julius II, whose intransigence was tempered by the offer of a princely remuneration: generous travel expenses, an annual salary of 1,200 ducats – about ten times the normal earnings of the average master sculptor – and the prospect of a further 10,000 ducats on completion of the tomb that Julius had commissioned. The tomb was to be the crowning glory of a series of increasingly pompous papal graves, a monument that would put the mausoleums of Imperial Rome in the shade. The Pope could hardly have chosen an artist more suited to such soaring ambition than Michelangelo. His plans were hardly modest: the first design he drew up comprised a three-storey architectural structure with more than forty life-size figures crowned by a three metre high statue of the Pope (*page* 73). This, in turn, inspired the Pope to think even bigger. Yet it soon transpired that the early Christian basilica, built on marshy ground, was not structurally sound enough to take such a monumental marble edifice. Pope Julius II decided to demolish it and concentrated all his energies on having it replaced by a central domed church designed by Bramante. In the meantime, Michelangelo was in Carrara, where the mountains inspired him to even greater flights of imagination – envisaging a colossal statue carved into the rock in the style of classical antiquity that would be a landmark to seafarers far and wide.

Michelangelo returned to Rome in 1506 after an absence of eight months, with a hundred tons of marble shipped in more than ninety consignments. With the rubble spreading out before St Peter's, the Pope became increasingly fixated on the new building. It transpired that he intended to postpone the tomb project. Then, to add salt to the wound, Michelangelo suffered the personal insult of being turned away rudely at the gates of the Vatican. On 17 April, he left the city in a dramatic gesture of anger. The following day, the Pope laid the foundation stone for the new St Peter's.

What Michelangelo himself described as the 'tragedy of the tomb' was to cast its long shadow over his life for forty years. He pursued the project with passion, love, hatred and finally with resignation. As soon as he had finished painting the Sistine Chapel he had more marble delivered at his own cost and after the death of Julius II he entered into a contract with the Pope's heirs to complete the project in the form of a wall tomb. He began work on the *Moses*, one of four figures planned for the second storey, and the *Slaves,* or *Captives*, which were to serve as Hermes figures for the lower storey of the tomb. Several contracts and design amendments later, the tomb was eventually installed

Sketch for a double tomb, 1520–21, pen and ink drawing, 21 x 15.5 cm, British Museum, London.

Tomb of Lorenzo de' Medici with the figures of *Dawn* and *Dusk*, 1524–31, in the Medici Chapel of S. Lorenzo, Florence.

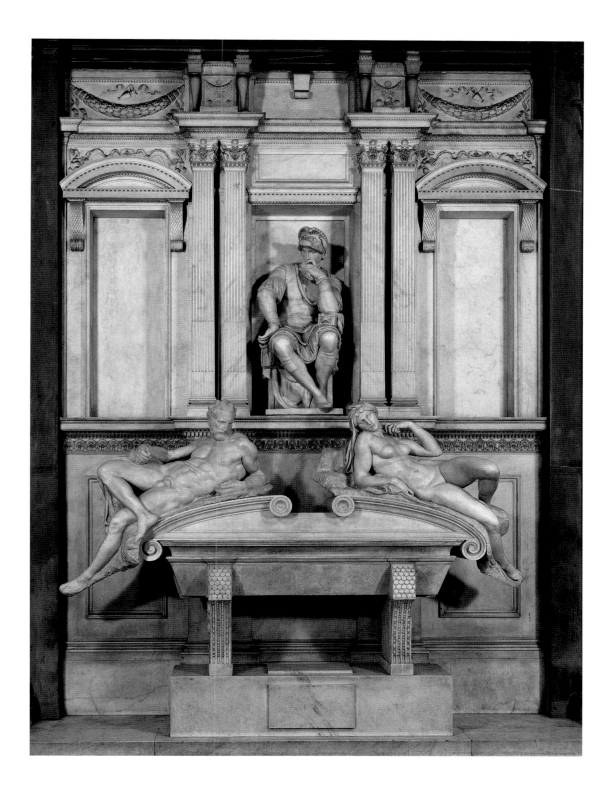

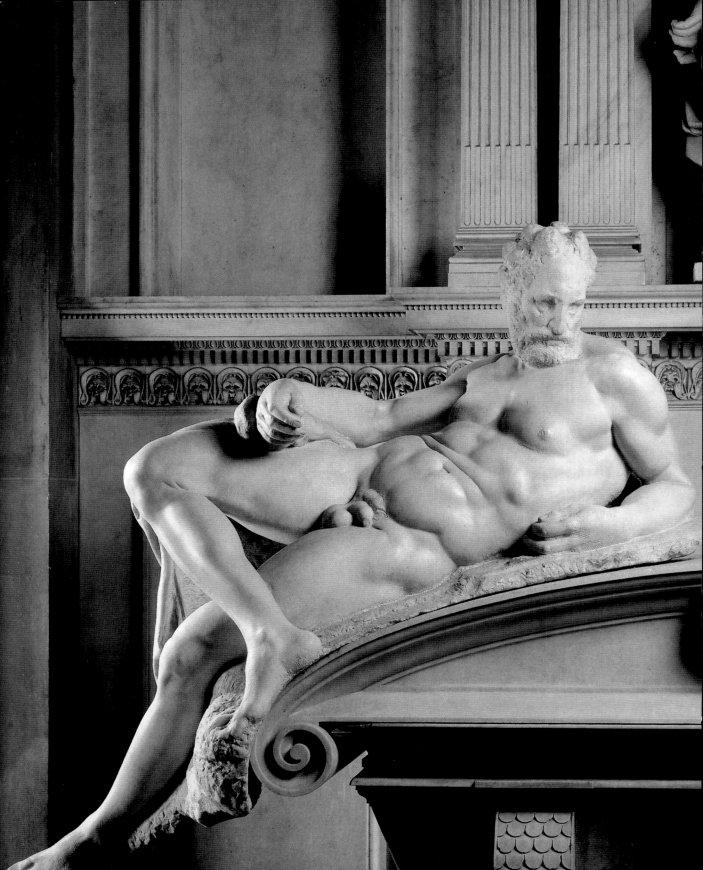

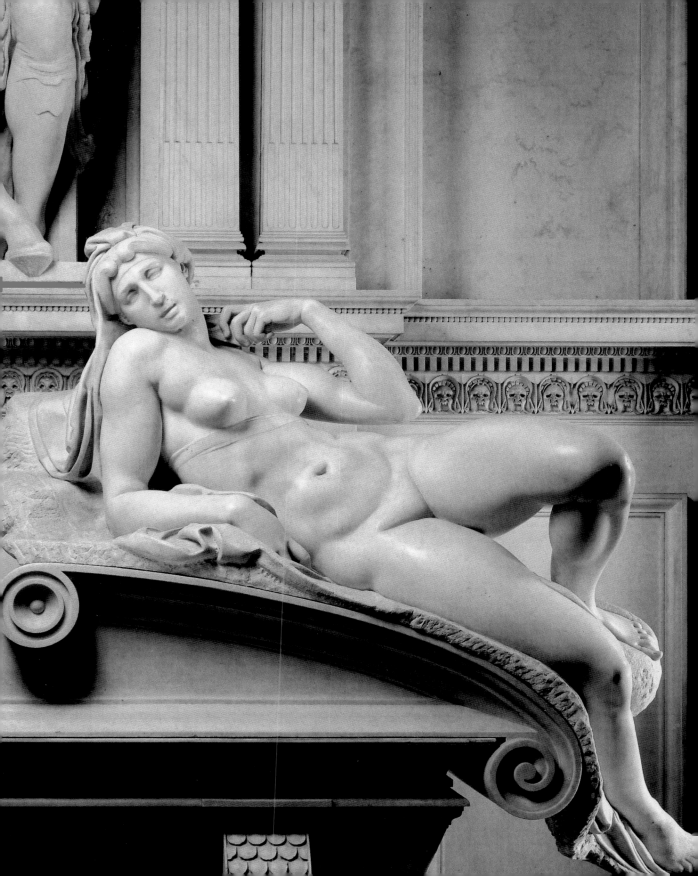

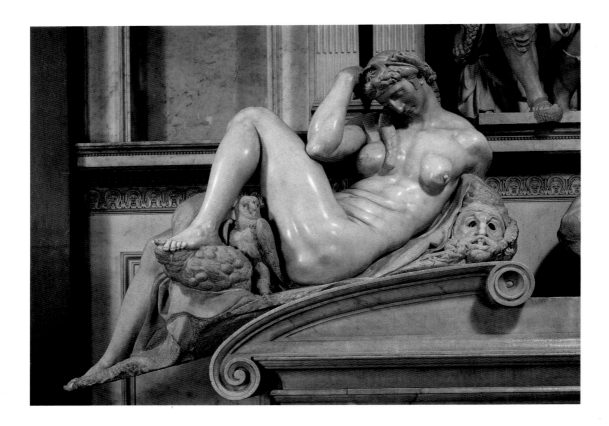

Allegorical figures for the Medici tombs:
Dawn and *Dusk* (pp. 76–77), *Day* (right)
and *Night* (above).

in S. Pietro in Vincoli, with the assistance of an army of students. Though Michelangelo himself insisted that the completion of this project was repeatedly hindered by external circumstances, especially by the intervention of successive Popes who repeatedly post-poned it in favour of other works, a closer examination of the situation does reveal the artist's own tendency to leave things unfinished by throwing himself with boundless enthusiasm into each new major project that came his way. In July 1516 he signed the third contract for the Julian monument, by now still further reduced in scope, and trav-elled once more to the mountains to quarry the marble. After three months in Carrara and Florence, he began planning the facade of S. Lorenzo, becoming so deeply involved in it that he eventually took on the entire project. He spent much of his time in the mountains of Carrara and Pietrosanta, seeking out new marble quarries and even building a new road for the transportation of the stone. Like the Julian monument, the facade of S. Lorenzo was delayed by the immense task of quarrying in the mountains,

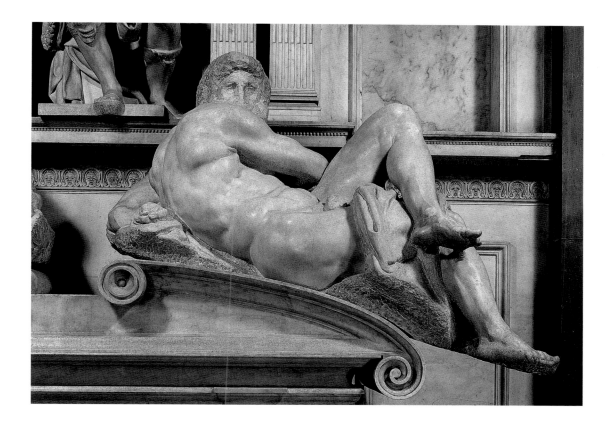

and, as time went on, the designs dreamed up by Michelangelo became ever grander. Yet still he attended to the smallest details of craftsmanship, working closely with the stone-masons, personally supervising the transportation of almost every single block of mar-ble, some weighing as much as seven tons, and painstakingly documenting the quality and history of each. Obsessed as he was with quality control, the very character trait that led Michelangelo to count out the pears in a basket also meant that he tended to become bogged down in detail. At the same time, the sculptor in him felt a need to work hands-on in the stone quarries as much as possible, nurturing his creative powers through this direct contact with the material that was the wellspring of his inspiration. He once told Condivi that this love of stone was something he had sucked in with the milk of his wet-nurse, whose father and husband were stonemasons in Settignano. Indeed, for many years, *la pietra* was the only great love of his life. *La pietra alpestra e dura* – the hard stone of the mountains – was to become a metaphor, from the late

1530s onwards, for the aristocratic Vittoria Colonna. When, in the course of his complex series of contracts for the unpredictable Medici, he ended up in a role akin to that of project manager, he increasingly lost this direct contact with the material in the marble quarries of the mountains, and, with that, he found himself deprived of a vital source of creative inspiration: "I am kept from the mountains by those who would rob me of spirit and reason."

To some extent, Michelangelo compensated in his poetry for this painful separation from his roots by attributing his inspiration to the fire of love. From 1538 the poetess Vittoria Colonna was the main addressee of his love poems and with her the stone came back into his life. Her name itself could hardly have been more apt: Colonna, the 'column' – a tall, hard, challenging, chaste 'mistress' of stone, a woman mature in years, and 'a man of a woman'. Through the stone metaphors in his poetry she becomes, at times, the 'good *concetto*' that he finds 'after many years and many challenges' in the 'hard mountain stone'. At other times she is the active sculptress who shapes and carves him, liberating him from his hard and rugged shell. Unlike many of Michelangelo's other love poems with their imagery of subjugation and humiliation, these tell of a mutual love – that of the sculptor and the stone, of adding and of taking away. "Just as, by taking away, lady, one puts / into hard and alpine stone / a figure that's alive / and that grows larger wherever the stone decreases."

The boundaries between active and passive are blurred in this existential symbiosis. "Even the best sculptor has not one idea [*concetto*] / that is not harboured within a single block of marble." As a sculptor who found not only his ideas but also his greatest risks and challenges in the stone itself, Michelangelo approached the material with enormous respect and high expectations. Ultimately, however, this sensitive and sensual approach to the material was at odds with his hugely ambitious designs. Originally, Michelangelo had intended to carve the forty larger-than-life figures for the Julian monument himself. Hardly any of them was finished when he began planning another forty large sculptures for S. Lorenzo. One figure took him several years. Working simultaneously on several statues, he would often work on deep into the night, seeking out the *concetto* of each individual block of marble while dozens of other blocks awaited their awakening. Even without the added pressure of circumstances, the *non finito* was surely inevitable in such a highly charged situation.

Two decades after his heroic achievement of the perfect *David*, Michelangelo increasingly allowed himself to be carried along by the actual process rather than trying to impress his own ideas onto the stone. Instead, he took his inspiration from the stone, allowing it to guide his hammer and chisel. The result was a new quality that no longer defined the *non finito* in the negative sense of *un*-finished. If the work of art itself is already contained within the stone, it may be said that little, if anything, is lost if it is not revealed in its entirety. The crucial creative act occurred much earlier – at the moment

when the genius of the sculptor recognised the *concetto* of the work within the stone, in the mountains. The rough-out stone and the traces of the stonemason's tools correspond to the sketchiness of a drawing or the fluent brushwork of a painted study. They document the emergence of the art work and are the authentic mark of the master's hand. From the 1540s onwards, even his contemporaries admired the Medici tombs for the genius of the *non finito* – a term coined by Vasari.

Even in the early stone reliefs, the *Battle of the Centaurs* and the *Madonna tondi*, it was already clear that Michelangelo deliberately left the surface unsmoothed and 'unfinished' as a conscious compositional element. In the reclining figures of the Medici tombs, we find every stage of completion juxtaposed, from the highly polished moon-like sheen of the body of *Night* to the rough face of *Day*. This unpolished face on a polished body illustrates that it was not a question of simply failing to complete the sculpture on grounds of time, but that the *non-finito* was an integral part of the work, irrespective of whether the head would have been too small had any more been carved away, or whether Michelangelo actually felt he had touched the core of the idea.

Michelangelo confronted the implacability of the individual stone, working each figure from a single block. No matter how carefully he selected the stones, the sheer size of them meant that he was bound to uncover a disfiguring vein now and again. Since he refused to improve flaws by adding other stone, he invariably found himself faced with limitations that forced him to make unplanned changes during the working process. It was a vein on the left arm of the figure of *Night* that prompted him to place the arm at the back and carve a mask to fill the space where the arm had originally been envisaged (*page* 146). The mask has the grimacing face of an old man, his few protruding teeth emphasising the lack of others. Could this be a satyr-like self-portrait set among the Medici princes in reference to the toothless faun he made for Lorenzo de' Medici? Michelangelo would abandon his original plan in order to follow the dictates of the marble and its inherent *concetto* – by taking away, he would peel yet another stratum of meaning out of the stone.

Michelangelo's stonemason sign on the block of the *Atlas Slave,* *c.* 1519 or 1530–34.

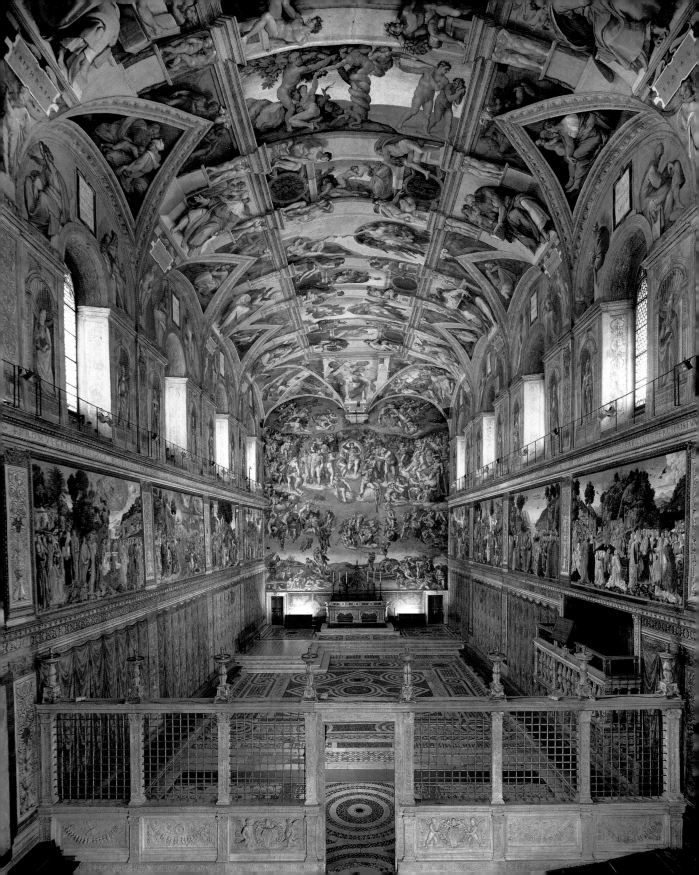

"I'm out of place here – and I'm no painter"

In 1511, with the work on the Sistine Chapel drawing to a close, Michelangelo was still venting his anger about being obliged to apply his talents in such an inappropriate genre: "But heaven is the one that scorns all virtue / if it puts it in the world, and then wants us / to go and pluck fruit from a tree that's dry."

Michelangelo spurs his horse through the dark night, pursued by five papal riders. About two o'clock in the morning, he crosses the boundary into the territory of Florence. Just as he falls exhausted into the bed of a hostelry, the Pope's men burst in, intent on dragging him back to Rome by force if need be. But Poggibonsi lies beyond the realm of papal jurisdiction, and so the couriers have to leave without him. Instead, they bring the Pope the artist's furious reply: that he will never return, having been driven off like criminal, that his faithful service had not deserved such treatment and that the Pope should look for someone else to serve him. The della Rovere ['oak'] Pope Julius II, who is referred to as a 'dry tree' in the poem, has a temper to match Michelangelo's own. The biographies by both Condivi and Vasari are full of such episodes, in which the hotheaded protagonists quarrel and even come to blows. Yet the impassioned confrontation between these two great visionaries bears unexpected fruits: the monumental tomb envisaged by the Pope becomes a cathedral, and the sculptor rises to the challenge by creating one of the most innovative works in the history of western art.

After his spectacular flight on 17 April 1506, Michelangelo settled in Florence and devoted his energies to completing some unfinished projects. All the while, he dreamt of yet another superlative work for a powerful patron – this time in Constantinople. Michelangelo imagined himself continuing in Leonardo da Vinci's footsteps by constructing the world's longest bridge across the Bosporus for Sultan Beyazit II. Eventually, the Pope's fourth attempt at persuading the artist to return did have some effect. By this time, the Pope had conquered Bologna, and it was feared that Michelangelo's stub-

Pope Julius II commissioned a reluctant Michelangelo to decorate the Sistine Chapel. It was to become his undisputed masterwork.

83

bornness would give him an excuse to extend his warring campaign to Florence. In 1506, the artist made his way to Bologna 'with the noose around his neck'. As he knelt before the Pope, his holiness made him an indirect compliment: "So, instead of your coming to meet us you have waited for us to meet you?" As a sign of his repentance, Michelangelo was to make a life-size equestrian statue of the Pope for the portal of the cathedral. Having encountered a number of problems in casting a figure of this size, it was finally completed in 1508, and Michelangelo was called to Rome. However, instead of continuing work on the Julian monument, as he had hoped to do, he found himself faced with yet another punishing task.

Michelangelo was to decorate the 1,100 square-metre ceiling of the Sistine Chapel. It was a project so loathsome to him that he even suspected his arch-rival, the architect Bramante, of having persuaded the Pope to commission him in a bid to ruin his reputation. 'Michelangniolo scultore' (as he still signed his letters until 1526), the sculptor whose skills surpassed even the ancients, was to squander his precious time on decorating a chapel that already bore the mark of all the finest painters of recent years, instead

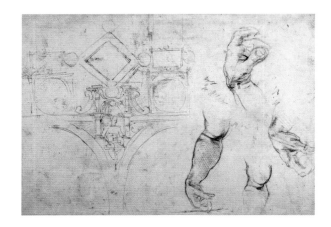

of being allowed to complete the tomb he envisioned as 'the finest in the world'. Built in 1480 by Julius' uncle, Pope Sixtus IV (Francesco della Rovere), the chapel was a showcase of Renaissance painting from Ghirlandaio to Botticelli and Perugino. In spite of the stylistic differences, the overall effect was one of unity, with the fresco cycles aligned in more or less symmetrically composed individual images separated by pillars and surmounted by figures of saints in trompe l'œil niches. Completing this rather outmoded design must have held little appeal for Michelangelo, who did everything in his power to be relieved of this burden.

The Pope, however, was insistent. He wanted Michelangelo to paint a series of the twelve Apostles in the lunettes above the windows and create a geometric ceiling decoration to replace the existing 'starry sky' decor that had suffered structural damage. Having signed the contract in May, Michelangelo set about ordering high quality pigments from Florence and putting together a team of experienced fresco painters under the leadership of his friend Granacci. If his initial lack of motivation had led Michelangelo to consider quickly dashing off a ceiling painting with a team of assistants while continuing his work on the tomb, he may well have underestimated his own perfectionism. In the course of the months during which the plasterers were preparing the ceiling, Michelangelo's designs began to take on a vitality that reflected his growing enthusiasm. Soon, the first tentative figures were starting to appear among the geo-

An early design for a geometric ornamental decoration of the Sistine Chapel, along with a study of arms and hands, pen and ink, pencil and charcoal deawing, 27.5 x 39 cm, British Museum, London.

metric ornaments *(left)*. The series of twelve Apostles requested by the Pope was dismissed by Michelangelo as a *cosa povere* [a poor thing], to which the Pope retorted that he could do whatever he wanted with the ceiling. Four years later, the ceiling was teeming with hundreds of figures instead of just twelve, and instead of the geometric ornamentation an entire world had been created. Michelangelo had taken his revenge, consciously or not, by creating a work as excessive as it is subtle. Unable to sculpt the tomb, he transposed its three-dimensionality into the two-dimensionality of the ceiling.

The side walls of the block-like tomb have been folded out like a flattened box. The pillars and entablature of the lower storey are retained, while the 'side walls' are curved by the form of the shallow barrel vaulting. On closer inspection, the architectonic structure appears as a strangely incongruous blend of rational illusionistic elements and irrational interactions. There is no uniform perspective that might correspond to a a view from below. The statics of the load-bearing elements are not to be trusted. What is actually bearing the load? This massive ceiling appears to be borne up by supernatural powers. Or is it already sinking downwards? This breathtakingly bold approach – a sense of temporary suspension – is achieved in a highly distinctive way. The starting point lies in the ornamental fields above the trompe l'œil niches originally envisaged for the fresco. This system of decoration inspired by Late Roman grotesque painting has been developed into a sculptural mode inspired by the vision of the Julian monument and taken still further to create a dizzying display of architectural imagination. Michelangelo had no intention of creating an organic spatial impression with this illusionistic proscenium. Instead, it served him as a framework within which he could place his many sculptures and reliefs.

In October 1508, after four months of preparations, grand visions and hundreds of sketches, the initial work on the Sistine Chapel seemed to be heading for disaster. Bramante's suspended scaffolding proved completely unsuitable, and Michelangelo set about constructing his own: a system of parallel flights of steps spanned across the vaulting and anchored in the walls half way along the chapel so that it was possible to move freely around one half of the chapel, relatively close to the ceiling, but without having a full view of the overall effect of large areas *(right)*.

Life studies and a sketch of the scaffolding for the Sistine Chapel, *c.* 1508, red chalk and pen and ink drawing, Galleria degli Uffizi, Florence.

The actual task of painting was also fraught with technical problems. In spite of his brief period of training under Ghirlandaio, Michelangelo had little experience of the complex art of frescoing. All this was further exacerbated by damp walls and a wet Roman winter. Having spent months working on the first scene, depicting *The Flood*, and having repeatedly replastered and repainted entire areas, spots of mould and salt efflorescence began to appear. The whole project was proceeding so slowly and unsatisfactorily that Michelangelo felt he did not even deserve payment, as he admitted in a letter to his father in January 1509, adding that "the problem with this work is that it [painting] is not my craft."

The *Entombment*, begun around 1500, was never finished.

The kneeling girl served as a study for the female figure on the lower left in the Entombment, *c.* 1500, black chalk, pen and ink in two colours, 27 x 15 cm, Cabinet des dessins, Musée du Louvre, Paris.

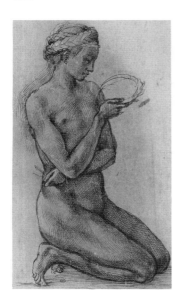

Michelangelo's artistic roots lay in the fresco painting of Masaccio and that of his former teacher Ghirlandaio. During his years in the Medici garden, he had concentrated entirely on sculpture. Then, in his first Roman period, the failure of his sculptures had forced him to eke a living by making altarpieces and designs for other artists in a modest workshop. Only two unfinished surviving works bear witness to these activities. One of them is the *Entombment* begun around 1500 *(right)*. Painted in the typically linear style of the Florentine school, its hard-edged fields of colour recall the *giornate* [day-work] of the fresco painters, but it nevertheless clearly betrays the hand of Michelangelo. The frontal nude figure of Christ foreshadows the *Slaves* or *Captives* of the Julian monument and the much later drawings and marble pietàs. Like the figure of Christ in the Roman pietà created around the same time, it shows Michelangelo's sound knowledge of anatomy, which was of such fundamental importance to his portrayal of the human form in painting as well. A sketch of a woman kneeling *(left)* suggests a less intense awareness of the more rounded forms of the female anatomy. This particular sketch is also a fine illustration of the typical approach taken by artists at that time: a life study of a nude followed by a portrayal of the same figure, this time with the addition of garments whose folds and draperies had been studied separately *(right)*. Whereas Leonardo honed his skill in the depiction of drapery to the highest degree, Michelangelo tended to leave this out wherever possible. His predominant theme was the nude male figure.

In Florence, in 1504, Michelangelo had the opportunity of vying directly with Leonardo in the portrayal of the male nude when he was commissioned to paint the *Battle of Cascina* for the Great Hall of Counsel in the Palazzo della Signoria as a pendant to Leonardo's *Battle of Anghiari*. Neither of these monumental frescoes ever got beyond the stage of the cartoons, which themselves were widely admired at the time, but survive today only in the form of copies. Elated by the success of his *David*, Michelangelo distilled the profound impression made by the Roman excavations, most notably the torso of Apollo, and his renewed anatomical studies in Florence *(page* 88) into a spectacular display of the male nude portrayed from every possible angle and in every conceivable pose *(page* 89). A comparison with the relief depicting the *Battle of the Centaurs* gives an insight into Michelangelo's artistic development. Ironically, the earlier marble relief appears much more painterly and more spatially coherent than the painted *Battle of Cascina*. One preparatory sketch of a soldier even looks like a polished statue *(page* 88). Here, we already find sculpture taking on the role attributed to it by Michelangelo as 'the lamp of painting'.

For all the frenzied action, the soldiers surprised while bathing appear isolated, and there is barely any indication of commonality in motion. The widely varied gestures and motions of the figures appear frozen, as in a film still. Leonardo's sketch *(page* 90) on the other hand melts the individual figures and gestures into a single physical, men-

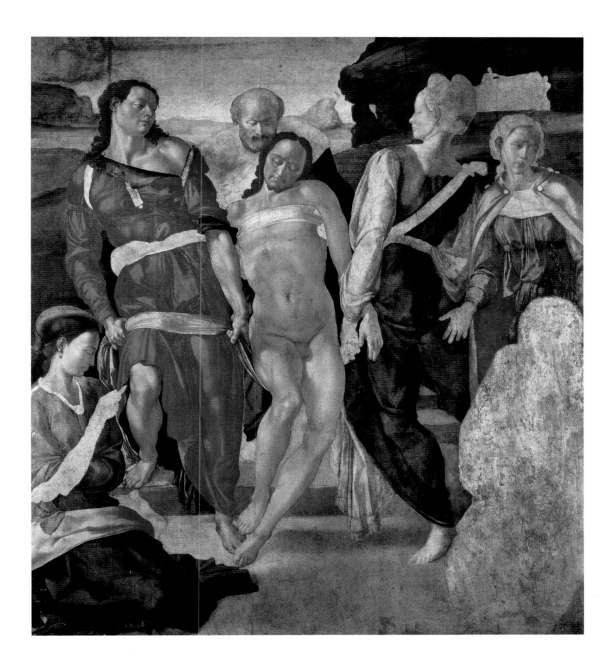

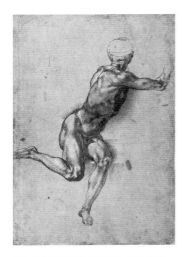

This accomplished study of a male nude can be found in Michelangelo's composition for the *Battle of Cascina*, pen and chalk drawing, British Museum, London.

Michelangelo's sound anatomical knowledge was the basis for his nude studies: study of a flayed body, 1515–20, The Royal Library, Windsor.

tal and spatial unit of dynamic movement. Whereas the sculptor has constructed the *Battle of Cascina* by adding together the monolithic statues, Leonardo has composed the figures into an image by painterly means. The inwardly circling movement of his pen and ink sketch creates a convincing spatial continuity, whereas Michelangelo's figures move only in the foreground and middle ground, like actors on a stage. Michelangelo did, however, respond to the dynamic scrum of Leonardo's group in his later work on the battle scene (*page* 91).

At the time, Leonardo's cartoon of *The Virgin and Child with St Anne* was causing something of a stir in Florence. It pointed towards a new possibility of achieving a sense of depth by means of soft-edged chiaroscuro rather than by the rules of central perspective. Michelangelo was clearly affected by this innovation, as shown by his Madonna reliefs of the same period (*page* 136). In his drawing, too, we find a shift from graphic hatching to a more painterly style involving lines of different thicknesses and varying tonality, with increased contrasts of light and shade, sometimes with the plasticity heightened by white highlights in the manner of Leonardo *(left)*. The *relievo* of the drawing provided Michelangelo with the perfect equivalent to his work in marble (*page* 19). Varying degrees of *relievo* can be achieved on paper as well, from painterly flatness to sculptural plasticity, portraying different degrees of *concetto* development from the sketchily outlined to the finely polished. The work of the sculptor, setting and lifting the chisel just as the draughtsman sets and lifts the pen, is not entirely dissimilar. The traces of his tools in the stone are like the pen-strokes in a drawing. In painting, on the other hand, the use of open and spontaneous brushwork only began to emerge in the course of the sixteenth century. Michelangelo, for whom this open approach to the creative process was so crucial in sculpture, found drawing the ideal medium in which to concentrate on his key theme of the human body without having to take into account the background, the perspectival depth or the overall composition. He could bring the *concetto* out of the flat and neutral paper with his pen in much the same way as he could release it from the monolithic block of marble with his hammer and chisel (*page* 148).

High Renaissance painting, however, required placing the human figure within a defined setting such as a landscape and putting it in a contextual relationship to other figures. Yet the idea of the painting as a window on an idealised reality was utterly alien to Michelangelo's approach, and landscape all the more so – even the Garden of Eden in his Sistine Chapel Ceiling is a sparsely vegetated wilderness. The only landscape he was really interested in was the landscape of the human body. It was the core from which he developed everything else: plasticity, space and composition. A picture was created first and foremost by the additive juxtaposition of several figures. Even Michelangelo's only surviving completed easel painting, the *tondo* of the *Holy Family* (*page* 92) he created in Florence between 1504 and 1506 for Agnolo Doni, possesses this collage-like character. A sense of space and depth is achieved only through the volumes and poses of the indi-

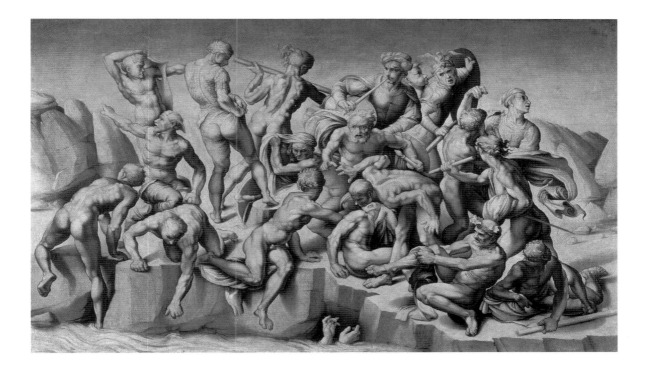

vidual figures in the foreground. Each figure constructs and inhabits its own space, and there is so little indication of any eye contact or communication between them that it seems as though it would be a minor miracle if they didn't actually drop the infant.

The view from the foreground into the landscape is partially blocked by a frieze of naked youths – hardly something conventionally associated with the iconography of the Holy Family – who add an element of classical physicality to an otherwise traditionally lyrical portrayal. Even the figure of the Virgin herself is unusually athletic, her bare, muscular arms evoking Michelangelo's description of Vittoria Colonna as 'a man of a woman'. The same head of the Virgin also appears in the figure of Jonah on the Sistine Chapel Ceiling (*page* 93). A much later example of the androgyny of Michelangelo's female figures can be found in his sketch of a young man's head as a preparatory study for *Leda* (*page* 91). Although it was indeed common practice at this time to use male models for life studies, other master artists did lend them a femininity that Michelangelo seems to have increasingly eschewed. Even in painting, he worked with sculptural volumes, which can be far more effectively portrayed in the muscularity of the male anatomy. Above all, however, almost all his classical models are male.

Michelangelo designed the *Battle of Casci-no* as a pendant to Leonardo's battle scene for the Great Hall of Council in the Palazzo della Signoria, Florence. This sole surviving copy of it is by Aristotele or Bastiano da Sangallo, *c.* 1542, grisaille on canvas, 76.5 x 130 cm, Collection of the Earl of Leicester, Holkham Hall, Norfolk.

Leonardo da Vinci, study of warriors on horseback and footsoldiers, 1503, pen and ink, 10.1 x 14.2 cm, Galleria dell' Accademia, Venice.

Michelangelo dismissed oil painting, as opposed to frescoing, as an 'art for women and weaklings' – primarily in response to Leonardo's mordant comments about sculpture. His own early painting is not even mentioned in Condivi's biography, and throughout his life he took scant interest in easel painting and was reluctant to accept orders for it. The hastily executed painting of *Leda* (*page* 145) that Alfonso d'Este persuaded him to create may indeed have been 'a mere trifle', as the unfortunate courier so carelessly remarked. Perhaps Michelangelo's reluctance to hand it over was also because he was unwilling to see his work compared directly with that of Titian in the Ferrara collection.

Not long after completing the Sistine Chapel Ceiling, however, and particularly from the 1520s onwards, he was happy to have his designs executed by such technically brilliant Venetian painters as Sebastiano del Piombo and Pontormo, whose handling of colour undoubtedly surpassed his own – for it allowed him to compete indirectly with Raphael and later with Titian.

Alongside this conscious division of labour – design and painterly execution – he set about developing a highly sophisticated art form in its own right that was as complex in form and content as any painting, but did not require the use of colour: the 'presentation drawing'. Most of these drawings were created as personal gifts for his closest friends, among them Tommaso Cavalieri (*page* 95) and Vittoria Colonna. In spite of their intimacy and symbolism, these works were celebrated and highly sought-after even in his own lifetime. In 1562, Tommaso Cavalieri, the recipient of most of these drawings, was even persuaded, much against his will, to give the *Cleopatra* (*page* 94) to

Battle Scene, c. 1506, pen and ink sketch, 17.9 x 25.1 cm, Ashmolean Museum, Oxford.

Duke Cosimo I de' Medici. Apart from the enormous prestige enjoyed by Michelangelo, this incident alone indicates how highly his drawings were valued as works equal to and even surpassing painting. Michelangelo himself regarded *disegno* [drawing] as the very essence of compositional form and certainly did not feel that his own contribution to the art of the cinquecento lay in daubing paint on panels or canvas, like 'women and weaklings'.

There is no false modesty in Michelangelo's lamentations about his 'dead painting' in his letters around 1509–10 and in his sonnet for Giovanni da Pistoia, or in his claim that he is 'no painter'. Competent as he may have been, and capable as he was of rendering each gesture with subtlety and of creating brilliantly detailed studies, any moderately talented painter of his day could create a more uniform pictorial space and landscape, though few could have mastered the central perspective and bold foreshortening demanded by the architecture and viewpoint of his ambitious Sistine Chapel project. While Michelangelo was wracked by profound self-doubt and was struggling desperately with his depiction of *The Flood*, just a few metres away, the walls of the papal *Stanze* were being decorated by a team of the very best fresco painters in all of Italy, handpicked by Bramante and headed by the brilliant Raphael. In early 1509, faced with the damage caused by winter dampness, Michelangelo was ready to abandon the project. But the Pope would hear none of it. Just how despondent he was is indicated by Condivi's report that Michelangelo himself even suggested putting Raphael in charge of the ceiling decoration. Under the circumstances, the willpower and sheer determination with which he succeeded in creating a highly ambitious synthesis of architecture,

Michelangelo's study of a head was made for his no longer extant painting of *Leda* for Alfonso d'Este, red chalk on paper, 35.6 x 27 cm, Galleria degli Uffizi, Florence.

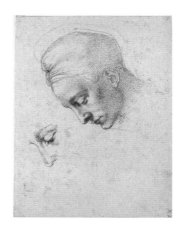

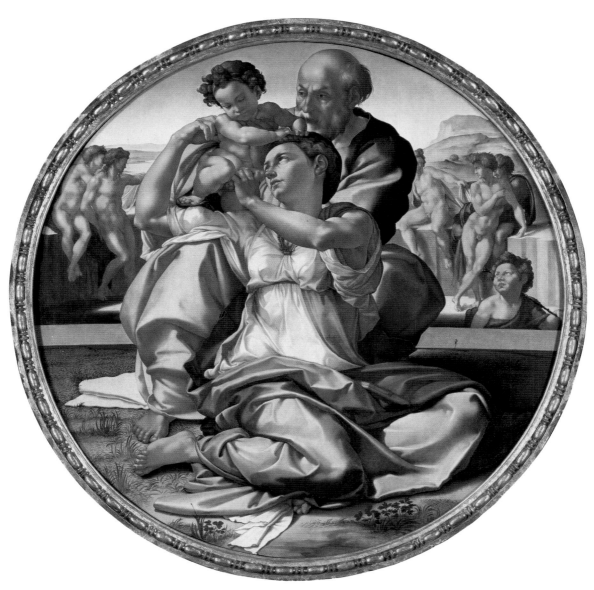

The only surviving finished painting by
Michelangelo is this tondo of the *Holy
Family*, 1504–06, commissioned by Agnolo
Doni and also known as the *Doni Tondo*.

sculpture and painting that not only liberated him from the oppression of his unwanted contractual obligation but also from his own perceived shortcomings as a painter was nothing short of heroic.

In 1508, Michelangelo was still no painter. This, indeed, probably explains why he broke so radically with the conventions of Renaissance painting. The revolutionary design of the Sistine Chapel Ceiling succeeded because Michelangelo did not approach the task with the eye of a painter, but with the mind of a sculptor. He began near the east wall with a device he had already deployed in the *Doni Tondo (left)* – by painting sculptures. Perched on the narrow ledges of the thrones, the large-scale figures of the prophets and sibyls seem as though they might tilt forwards out of the picture plane at any moment. Other figures, like the monochrome caryatids, merge into the background like architectural reliefs. The *ignudi* undergo a change in the course of the project – beginning as little more than architectural decor, they take on an increasingly prominent role. This development can be seen by comparing the first *ignudi* to the upper left of Joel with the later *ignudi* above Jeremiah (*pages* 98f.).

The lunettes above the windows, originally intended to show the twelve Apostles, form a calmer area of transition to the fresco cycles. In order to ensure that the *Ancestors of Christ* could be seen against the light falling through the windows, Michelangelo used his famously shimmering colours (*pages* 96, 97) – just as he had previously done to create the luminosity of the *Doni Tondo*. Being able to paint the lunettes standing upright meant that work progressed apace, as the *giornate* indicate – about three days for each figure. Soon, Michelangelo felt confident enough to work without a cartoon, sketching the preliminary drawing directly onto the plaster and painting it in relatively free brushwork. He had become an accomplished painter.

It took much longer to paint the main narrative scenes. Michelangelo struggled with the fresco technique and the cartoons and was hampered by the extremely uncomfortable working position (*page* 27). The first three scenes, in particular, up to *Noah's Sacrifice*, were fraught with difficulty, and it took Michelangelo a year to find a way of combining the nudes and massed figures into a coherent image. Only with Adam and Eve did he find himself on more familiar territory. He soon abandoned the notion of creating a uniform pictorial space; a few landscape elements would suffice, and everything else would be embodied by the monumentalised figures themselves. The fluent brushwork he had developed in the lunettes now permitted him to paint at a faster rate. In the end, Michelangelo even painted the main scenes straight onto the plaster without cartoons.

In August 1511, after a break of more than a year, the first half of the Sistine Chapel Ceiling was unveiled and the scaffolding erected for the second half. For the first time, Michelangelo could ascertain the overall effect of the finished section. His reaction was to continue in the same vein, but with greater vigour.

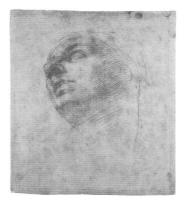

This study of a head looking upwards was made for the figure of the Virgin in the *Doni Tondo*. It was also used for the head of *Jonah* in the Sistine Chapel. 1504–06, red chalk, 19.9 x 17.2 cm, Casa Buonarroti, Florence.

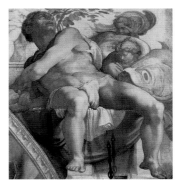

Bold foreshortening is used for the figure of Jonah. Detail of the Sistine Chapel Ceiling.

Starting with *The Creation of Adam* (*page* 100), the sweeping movement of the individual figures, and especially the increasingly dynamic gestures of the *ignudi*, now spilled over into the central scenes as well, creating a heightened sense of dramatic tension. Whereas, in *The Creation of Eve* (*page* 101), the figure of God still had the air of a quietly benevolent elderly patriarch, He was now portrayed hurtling through the heavens in a frenzy of movement that verges on the Baroque. Michelangelo had created archetypes that were to hold sway for centuries – right through to the comic strips of our own era – such as the whirling figure in the *Division of Light and Darkness* (*page* 99).

The central section has no narrative scenes or isolated figures. By abandoning the self-contained homogeneity of the individual image – which had never been his priority anyway – Michelangelo enhanced the overall uniformity of the whole. He did so, not by means of a single system of reference such as perspective and composition – as Leonardo had done – but by means of a physical and mental dynamic that swept everything along with it. Everything is generated by the sheer energy of the *furor divinus* creating the sun and tousling the hair of the *ignudi*.

The sense of augmenting excitement that gathers pace as it develops from the entrance wall towards the altar wall, is reflected not only in the poses of the *ignudi*, but also in the vitality of the architectural ornamentation. The caryatids, still quietly immobile on the relief of the throne of Zecharia, become increasingly animated in the course of the fresco until, by the time we reach the throne of Jonah, they look as though they might be up and off at any moment. A comparison of Zecharia (possibly a portrait of Julius II) with the boldly foreshortened figure of Jonah at the opposite end of the ceiling is an impressive illustration of the enormous progress made by Michelangelo as a painter in the course of these four years.

In terms of athletic physicality, too, we see a remarkable development: more energy, more movement, more speed, more muscle. The physical muscularity of the *ignudi* was influenced by the Belvedere Apollo and, most notably, the Laocoon Group (*page* 104), which Michelangelo had seen excavated in Rome in early 1506. The dynamically spiralling movement of the *figura serpentinata* was an inspiration to him, as was the expressive muscularity of the male body tensed in action. Michelangelo's women are also portrayed according to this particular ideal of beauty. The androgynous sibyls and even the archetypal Eve of *The Fall* have a distinctly masculine bias. In accordance with the Neoplatonic ideal, it is the strong male anatomy that is the crowning glory of divine creation – in His own image. On the other hand, never before has God appeared in such a muscular earthly form. In *The Creation of the Sun, Moon and Planets*, but for the fluttering robes, what we see looks for all the world like a sprinter leaving the blocks (*page* 100).

Michelangelo's drawing of *Cleopatra*, *c.* 1533–34, was a gift to Tommaso Cavalieri, who had to hand it over to Duke Cosimo de' Medici. Black chalk, 35.5 x 25 cm, Galleria degli Uffizi, Florence.

Another of his presentational drawings is *The Dream*, created *c.* 1533, Courtauld Gallery, London.

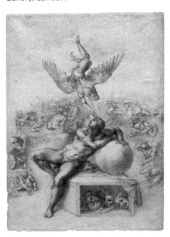

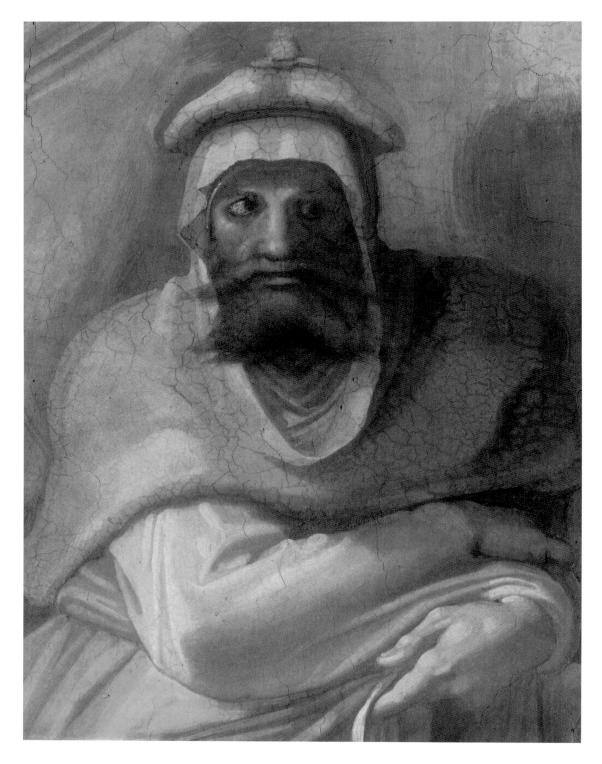

Michelango used intensely shimmering colours for the lunettes of the Sistine Chapel
Ceiling. The details show *David* (left) and *Manasse* (right).

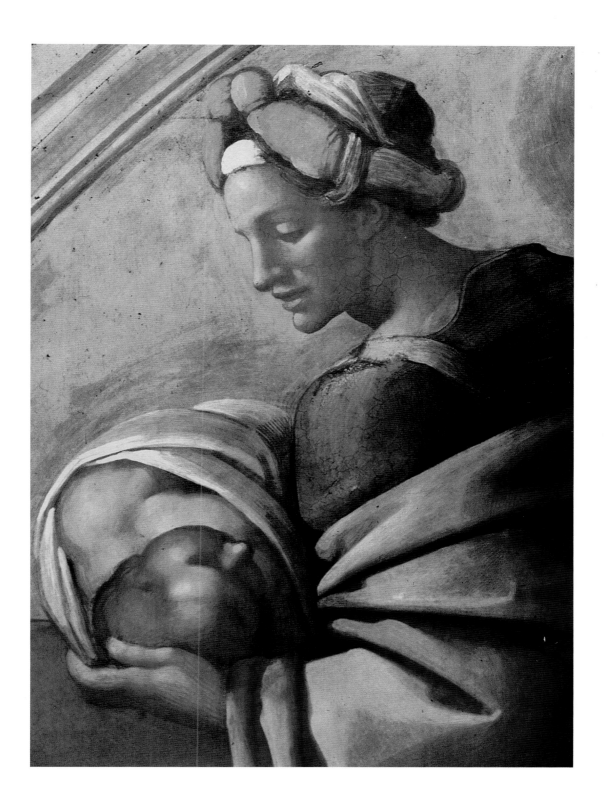

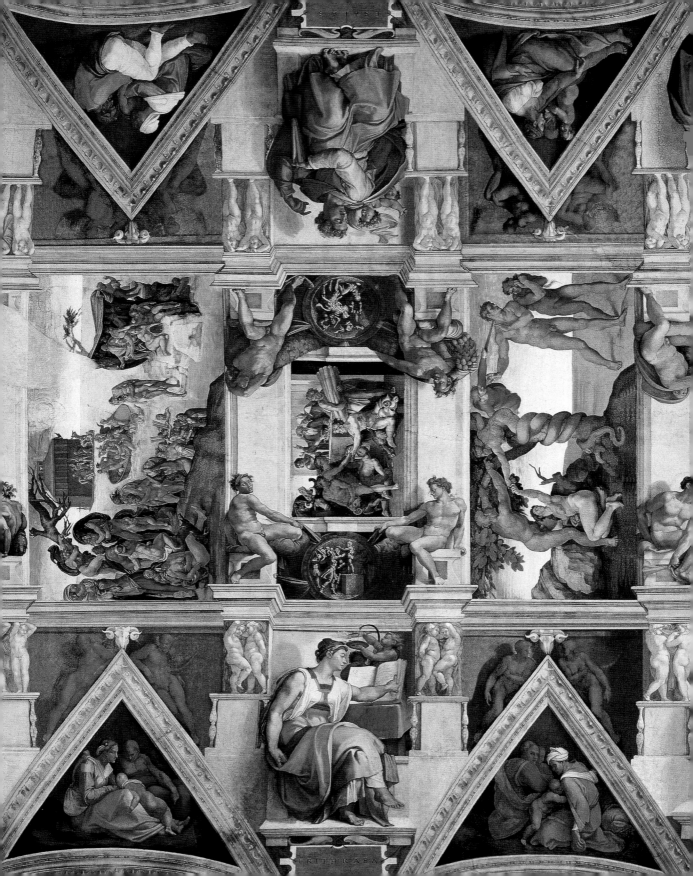

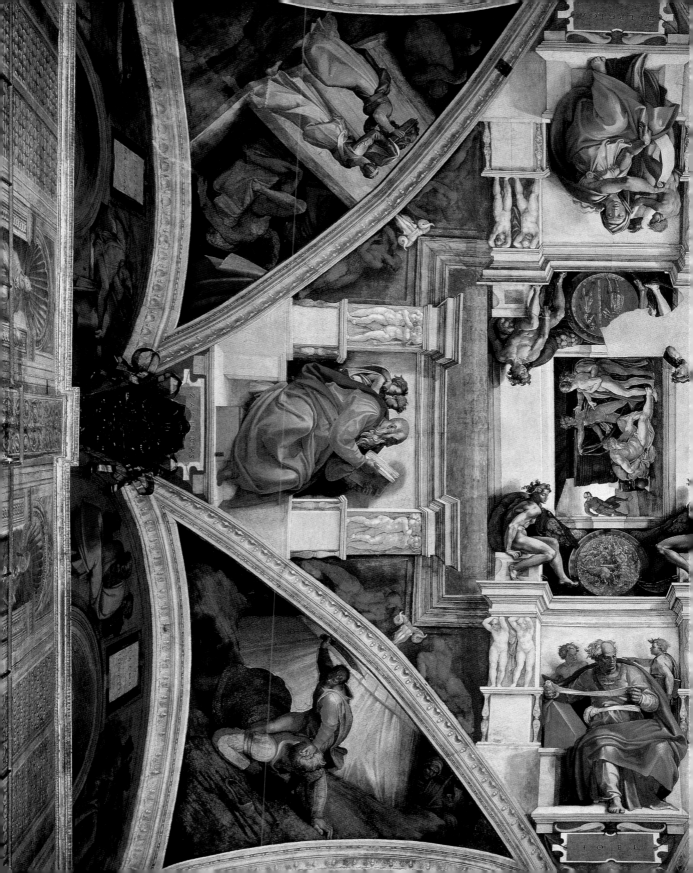

The ceiling fresco in the Sistine Chapel

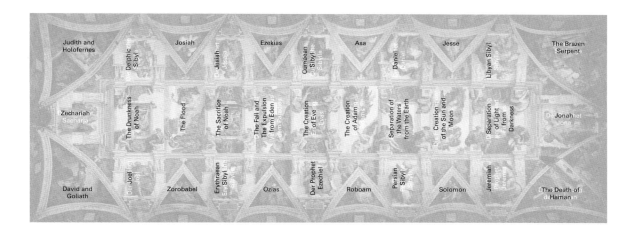

Judith and Holofernes

Delphic Sibyl

Josiah

Josiah

Ezekias

Cumaean Sibyl

Asa

Daniel

Jesse

Libyan Sibyl

The Brazen Serpent

Zechariah

The Drunkness of Noah

The Flood

The Sacrifice of Noah

The Fall and The Expulsion from Eden

The Creation of Eve

The Creation of Adam

Separation of the Waters from the Earth

Creation of the Sun and Moon

Separation of Light from Darkness

Jonah

David and Goliath

Joel

Zorobabel

Erythraean Sibyl

Ozias

Der Prophet Ezechiel

Roboam

Persian Sibyl

Solomon

Jeremiah

The Death of Haman

ZECHIEL·

The Last Judgment on the west wall of the Sistine Chapel. The composition is some 17 m high and more than 13 m wide.

Three years later, Michelangelo was to indulge in a veritable feast of physicality with his *Last Judgment* for the altar wall of the Sistine Chapel, commissioned by the Pope in 1534 (*page* 105). Once again, it was a project he was reluctant to undertake. By the time it was unveiled in 1541, it had become a teeming, tumbling mass that poured all the way across the wall and right down to the altar. This was truly a resurrection of the flesh: a seething mass of hundreds of naked bodies, caught up in the ecstasy of their salvation and the despondency of their damnation. Some of the figures feature on the ceiling, too: at the lower right-hand corner, we find the Cumaean Sibyl in the caricature of a figure entwined by a snake. Here, though, it is no longer the beauty of the male physique at the dawn of man's creation that is the main theme – though it is still reflected in the figure of Christ/Apollo/Cavalieri – but the human body in every state of desire and torment, in all its glory and decay at the end of all things. The sense of unease triggered by this fresco found expression in vitriolic criticism of its display of uncovered genitalia and of the sometimes ambiguous poses of the saints "in various positions that the most sacred religion did not attribute to them," as Veronese later remarked. Shocked contemporaries saw the altar wall of this chapel at the very heart of Christendom transformed into a transcendental Roman bath-house. One of the most vociferous critics, the papal master of ceremonies Biagio di Cesena, is said to have condemned Michelangelo forever in the figure of Minos, the judge of Hell, entwined by a snake, in the lower right-hand corner. After two decades of heated and polemical debate, the *Last Judgment* finally fell foul of the Counter-Reformation censors: in January 1564, just four days after Michelangelo's death, it was decreed that the 'obscene' parts be covered up. Michelangelo's student Daniele de Volterra was commissioned to paint loin-cloths on the figures in the *Last Judgment.*

The Late Hellenist *Laöcoon Group*, marble, 242 cm high, Museo Pio Clementino, Vatican, Rome. Michelangelo witnessed their excavation and they inspired his athletic Ignudi.

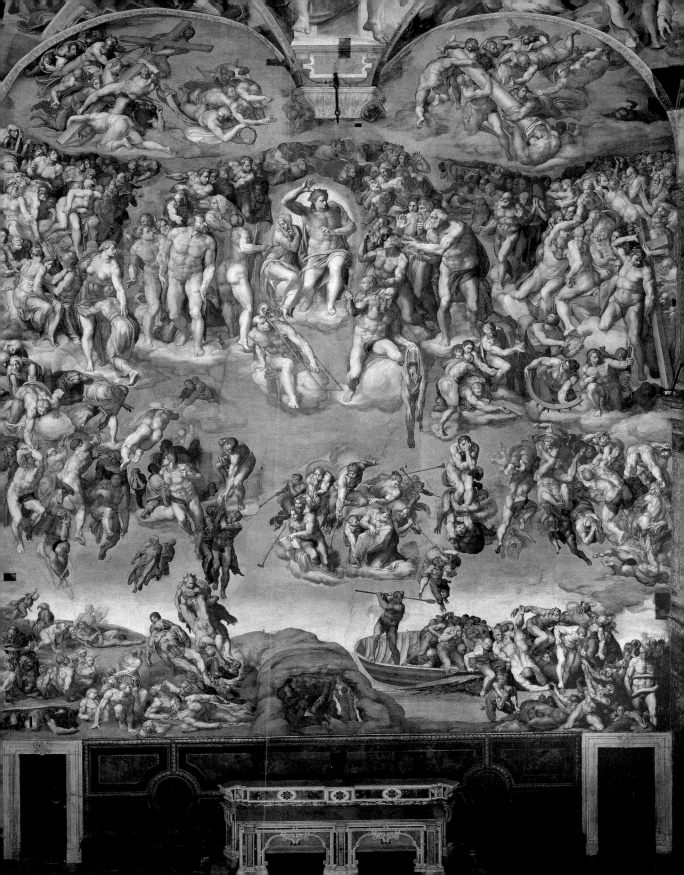

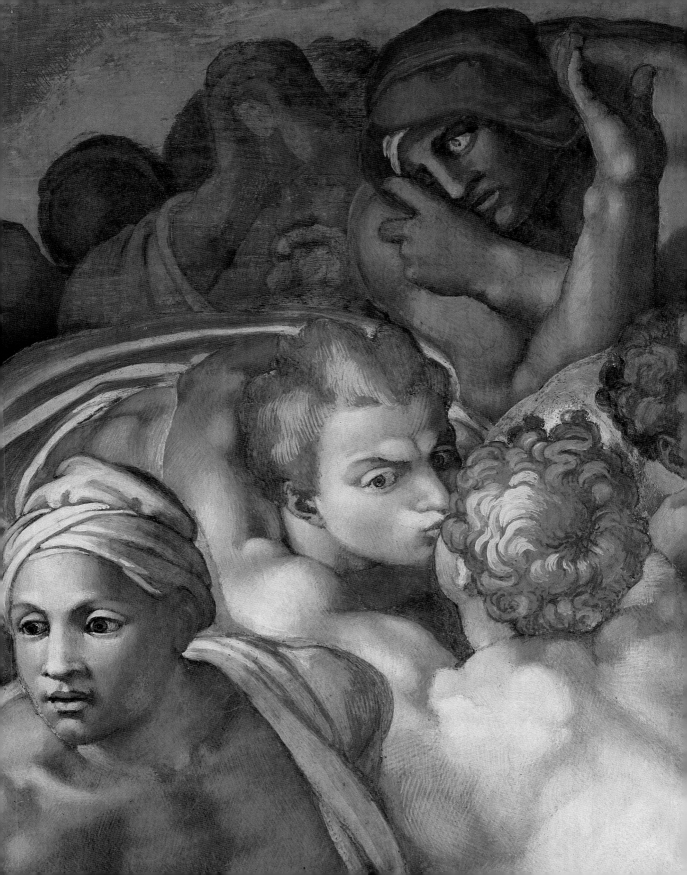

In the Service of the Creator – Michelangelo as an Architect

Michelangelo outlived them all – Bramante, Raphael, Peruzzi, Sangallo. In the end, he was the one who made his mark on St Peter's. Yet he claimed that this victory was one of his 'greatest losses'. In his old age, he endured for seventeen years as the chief architect of St Peter's. Though his most implacable patron now was God Almighty and the building itself both a burden and a heavy moral responsibility, it nevertheless brought him triumphant compensation for the 'tragedy of the tomb' that was the Julian monument.

"As far as my depature is concerned, the truth is that on Holy Saturday I heard the Pope … say that he did not want to spend another *baiocco* on stones, whether large or small." With these words, Michelangelo describes the beginning of what was to become, for him, the 'tragedy of the tomb'. Had he actually completed this monument, it would have taken him a lifetime. But from this heap of abandoned stones he would draw some of his most important ideas and, in the course of the decades that followed, the unfinished tomb that was constantly changing in his mind's eye came to represent the agonising yet fertile *ostinato* of his creativity.

The pyramid-shaped freestanding tomb he designed in 1505 (*page* 73) was transformed under the influence of his two-dimensional work on the Sistine Chapel Ceiling into the hybrid form of his 1513 design (*right*) surmounted by an arch that echoes the spandrels of the fresco architecture. In this design, the side of the tomb was placed against the wall, but the structure as a whole still protruded far into the room. Subsequent design alterations compressed it further, but gave it more width and height. In the contract of July 1516 it is described as a two-metre deep wall tomb (*page* 110); the version ultimately installed in S. Pietro in Vincoli in 1542 is even shallower. Influenced by the two-dimensionality of painting, the plasticity of the sculptures receded further towards the wall, creating the effect of a deep *relievo*. In the Sistine Chapel frescoes, the figures had become increasingly emancipated from the notions of architectural structures. In the various stages of the tomb project, the same process can be traced in reverse, with the architecture becoming increasingly emancipated from the reductive

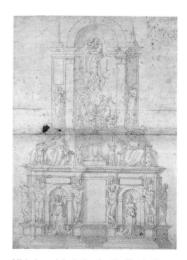

Michelangelo's design for the *Tomb of Julius II* is preserved in this copy by Giacomi Rochetti, pen and ink, 52.5 x 39 cm, Staatliche Museen zu Berlin.

Stairway leading to the Biblioteca Laurenziana in Florence, Michelangelo's most important work of architecture.

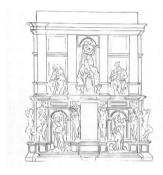

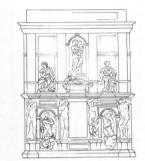

Reconstructions of Michelangelo's designs for the *Tomb of Julius II* in 1516 (top) and 1532 (bottom) after Giulio Carlo Agan.

sculptural ornamentation until, finally, in the 1516 project, the second storey takes on the form of a triumphal arch and is largely determined by the architectural structure.

The sculptor Michelangelo had developed as a painter and had finally become an architect. Ironically, the further his designs shifted from three-dimensional sculpture towards two-dimensionality, the more tectonic they became. As a painter, his work on the Sistine Chapel drew primarily on the plasticity of sculptural forms placed in the foreground (compare the *Doni Tondo* on page 92). In architecture, too, he took a similar approach. Here, it is the socles, columns, pilasters and other elements that define a relatively flat sculptural zone. Michelangelo does not build on the basis of a pre-determined three-dimensional rational construction with load-bearing elements in the available space, but seems instead to model or carve out forms from the material, step by step. Going still further, in his exaggerated formulation of the stairway leading up to the Biblioteca Laurenziana, one has the impression that the sculptural mass in the base course of the vestibule has taken on a life of its own *(lower left)*. Michelangelo created a clay model for what is the first sweepingly curved stairway of this kind in architectural history and was eventually persuaded to send his design to Florence. In 1525, the plans still envisaged a rectangular pyramidal structure, though Michelangelo was reluctant to recall this fact: "A certain staircase comes to mind mind just like a dream, but I don't think it can be the same one I had in mind originally since it seems so awkward."

Pope Leo X, Michelangelo's boyhood friend Giovanni de' Medici, entered Florence in triumph in November 1515. As the most prominent member of his family and of his native city, he had achieved the highest office and now sought a suitable means of expressing this status outwardly. The entire area of the Medici dynasty's original home, including the palace, was to be redesigned, starting with a facade for Brunelleschi's unfinished basilica of S. Lorenzo. Several leading architects were involved in the planning phase, among them the favoured Vatican court architect Raphael. It may be assumed that Raphael was to supply the architectural design, and Michelangelo the sculptures and reliefs. This time, however, the sculptor Michelangelo beat all comers to secure the contract for himself in October 1516, working with the Florentine architect Baccio d'Agnolo. An outsider in this field, he encroached aggressively on Raphael's territory to claim it for himself in his home town of Florence.

Michelangelo could now have concentrated all his energy on the Julian monument, but the political power of the della Rovere clan was waning and so the sculptor looked instead to the new centre of power. In the course of 1516, in spite of renewed contracts for the tomb of Julius II (already reflecting elements of the facade design) Michelangelo set about doing everything to gain control of the S. Lorenzo project. In the summer, he travelled once more to Carrara to select new marble for the tomb, but in the mountains, ever a source of inspiration, his visions were focused on S. Lorenzo. Starting with a three-storey stepped facade featuring freestanding pairs of columns *(upper right)* – not

unlike the original stepped pyramid of the Julian monument – he gradually widened the structure, much as he had done in the tomb designs. Soon, however, Michelangelo became dissatisfied with the structural emphasis of the first specific design *(lower right)*, drawn up in collaboration with Baccio, and dismissed Baccio's imprecise model as "childish stuff".

In the spring of 1517, Michelangelo persuaded the hesitant patrons Pope Leo X and his cousin, the Florentine archbishop Cardinal Giulio de' Medici, to give him full control of the entire facade design. The wooden model that finally won him the contract was not completed until December 1517 *(page 112)*. Instead of a classicistic approach emulating the architecture of antiquity, it shows a rectangular facade based on the 1516 design for the Julian monument. It is neither a wall nor an entirely three-dimensional structure, but an edifice built of heavy marble blocks with revetments and twelve monumental columns. True to form, Michelangelo soon turned the classical column order into something entirely different. By shifting the base course to the mezzanine of the augmented upper storey, the compressed main storey seems to bear down upon the base in defiance of all the rules of engineering, while the columns themselves recall the atlants of the *Slaves* or *Captives*.

Michelangelo thus created a distinctive new form that is more spatially structured than the traditional facade of thin marble panels cladding a wall of brick, yet flatter than the temple portico that is an outward projection of the basilican form of the aisled church.

Although another wooden model originally included wax figures, Michelangelo's drawings indicate that the statues and reliefs in this case are more complementary in character *(page 113)*. Even in his capacity as a sculptor, he was now thinking in terms of the architectural forms of classical antiquity, but instead of applying them structurally, he treated them – in complete contrast to their static logic and formal tradition – as sculptural material to be formed at will. "I feel capable of doing this work, the facade of San Lorenzo, so that it can be the mirror of all Italy in architecture and sculpture…"

Once again, Michelangelo was promising his patrons "the most beautiful work ever created in Italy." By building the first solid marble structure since the days of Ancient Rome, Michelangelo vied ambitiously with the architects of classical antiquity – not in emulation but in an original new formal

Raffaelo da Montelupo, copy of the Michelangelo design shown below, Musée des Beaux-Arts, Lille.

Design for the facade of S. Lorenzo, Casa Buonarroti, Florence.

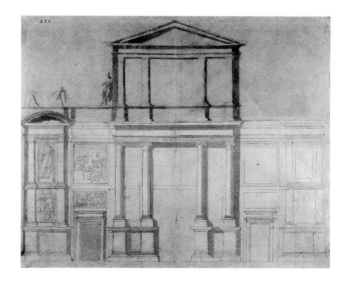

syntax. Whereas his *David* had posed the challenge of carving a gigantic sculpture out of a single block of marble more than five metres high, the challenge of S. Lorenzo lay in creating twelve monolithic six-metre tall columns as the main features of the facade.

The *David* sketch bearing the self-assured remark 'David with the sling and I with the bow' also has an additional comment that is a reference to Petrarch: "broken is the high column and the green…" Though it has never been entirely clear what exactly this is supposed to mean, it does make a close connection between the figure of the 'giant' and the column as an abstraction of the human form. What is more, the column is the very embodiment of antiquity. Possibly, Michelangelo is insinuating that he has slain the Goliath of the classical column with the weapon of his craft. And now even classical architecture is to be surpassed by 'the most beautiful work ever created in Italy', with the stone-carved colossal column as its key measure. As in the sculpture, here too, it is a technical detail of craftsmanship that has ignited Michelangelo's passion to the point of obsession. After all, a column built of several elements has much the same effect in

This wooden model made by Michelangelo in 1517 won him the contract to design the entire facade of the church of S. Lorenzo in Florence.

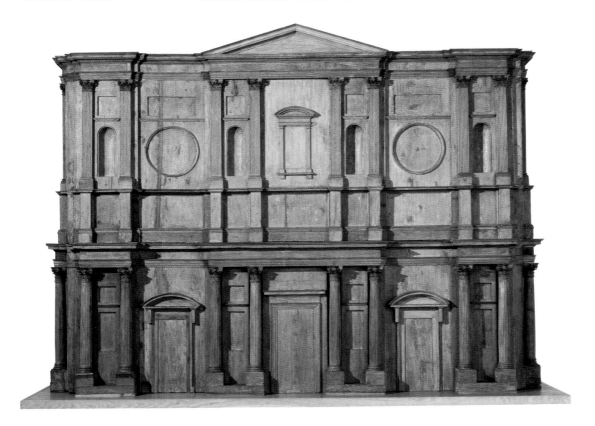

terms of purely architectural form. For Michelangelo, how-
ever, what counts – and what justifies the laborious effort
of quarrying the stone – is not so much the outward
appearance as the unfragmented individuality of the single
marble block. In his architecture, as in his sculpture, he
finds the crucial *concetto* within the stone itself. The largest
monolithic round columns of Ancient Rome were the six-
teen Egyptian granite columns of the Pantheon. The
columns in the old basilica of Constantine were brutally
destroyed for the rebuilding of St Peter's – a fact that did
not leave Michelangelo unmoved. He had no wish to use
the ancient columns, as was so often done in the Renais-
sance, nor did he seek to reproduce the achievements of
classical antiquity. He wanted to surpass them with a new

Sketch of the façade of S. Lorenzo, 1518.

creation: twelve identical columns of pure white marble were to grace the facade. The
technical and financial outlay involved in obtaining these 'giants' was unparalleled. The
main work of quarrying them began in 1518, not in Carrara, but in the extremely
remote quarries of Seravezza, for which a new road had to be purpose built. Without
the experience of antiquity, a whole new technology had to be devised. Once the first
block had been quarried, it took an entire month to obtain special ropes and pulleys
from Florence, and another three months to transport the stone down the rock face to
the loading point. The cost of this alone ran to the princely sum of sixty ducats. In the
Vatican, the progress was followed with bated breath – a monolith of this size had not
been transported in a thousand years. Michelangelo already had his eye on a thirteen-
metre block. But the second column was broken in the process of lowering it down the
mountain, and two or three others subsequently broke as well. In one incident, a stone-
mason was killed and Michelangelo and his assistants only narrowly escaped death.

Special barges had to be built for the columns, each weighing between eight and ten
tons, to carry them 150 km by sea and up the River Arno. In early 1520 one block
almost sank in the river near Pisa. Inclement weather, tides and water levels caused
repeated delays. On their way to Florence, the blocks had to be loaded and unloaded
five times using specially constructed cranes, and the last leg of the journey was by ox-
drawn cart. In 1519 most of the smaller blocks arrived in Florence. The legendary first
column was the only one to reach S. Lorenzo in April 1521. Michelangelo was in his ele-
ment 'taming the mountains'. In tackling the technical and artisanal challenges of quar-
rying and transportation, and in supervising this enormous logistic operation, he dared
as no other did to measure himself with the ancients.

Yet his patrons tended to have less patience with the long course of history in the
making, and began to lose all hope of seeing their project completed, given the battles to

obtain the material and the delays in the delivery of the marble. The realistic but no less megalomanic Julius II turned his attention instead to the new St Peter's, while the more business minded Medici Pope Leo X responded with resignation. The building costs, initially set at a generous 25,000 ducats were raised by Michelangelo in his final contract to 40,000 and looked as though they might rise still further. In March 1520 the Pope cancelled the façade contract.

Michelangelo complained bitterly to a friend about this 'enormous insult', about the financial loss and the time wasted, but he nevertheless continued to work in the service of the Medici, undertaking smaller-scale projects that bore little relationship to his visions of a triumphal facade. The trauma of the Julian monument was repeating itself – all the more galling in view of the Herculean labours and flights of imagination that he had undergone in recent years.

One ray of light in this gloomy spring of 1520 was the sudden and unexpected death of Raphael. Michelangelo immediately set about having the painter Sebastiano del Piombi installed in the Vatican to keep the school of Raphael out of the running. In terms of status, at least, Michelangelo was now the undisputed star.

In terms of his creative fulfilment, however, many crucial issues remained unresolved, many ambitions thwarted, and Michelangelo was aware that time was no longer on his side. Something of the sense of frustration, urgency and setbacks of these years can be felt in his subsequent architectural project. Since the death of the young Lorenzo de' Medici in 1519, work had been continuing on the creation of a tomb, as a pendant to the overcrowded family tomb in Brunelleschi's Old Sacristy in S. Lorenzo, at the other end of the transept. Michelangelo may well have been involved in the initial plans, but in 1520 he was transferred from his ambitious and already promising work on the colossal foundations of the façade to become the official architect of this new mausoleum.

Just as he had been obliged to abandon the Julian monument in order to work on the Sistine Chapel Ceiling, he now found himself having to give up his visions of a supreme work of art in order to take on a very different project on a much smaller scale. Since the tomb was to be a pendant to Brunelleschi's cubic domed structure, Michelangelo was once again tied down to an older Renaissance pattern. And, as in the Sistine Chapel, he once again succeeded in finding a revolutionary new solution: he radically blended the stereometrically balanced forms of the Early Renaissance with the sculptural plasticity of his facade design.

What had once been a massive façade is now wrapped around Brunelleschi's crystal of perfect rationality, dominating the relatively small interior space. The white marble and stucco architectural motifs of the facade jostle for position among the dark stone central structure of the Old Sacristy. Given the limited space, it is hardly surprising that the niches are so deep, and that the tabernacles beneath the windows seem to push forwards

View of the cupola of the Medici Chapel in S. Lorenzo.

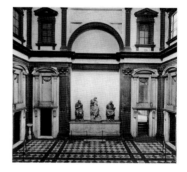

South wall of the Medici Chapel.

Pages 115/116
Interior of the Medici Chapel, which Michelangelo worked on from 1520–34.

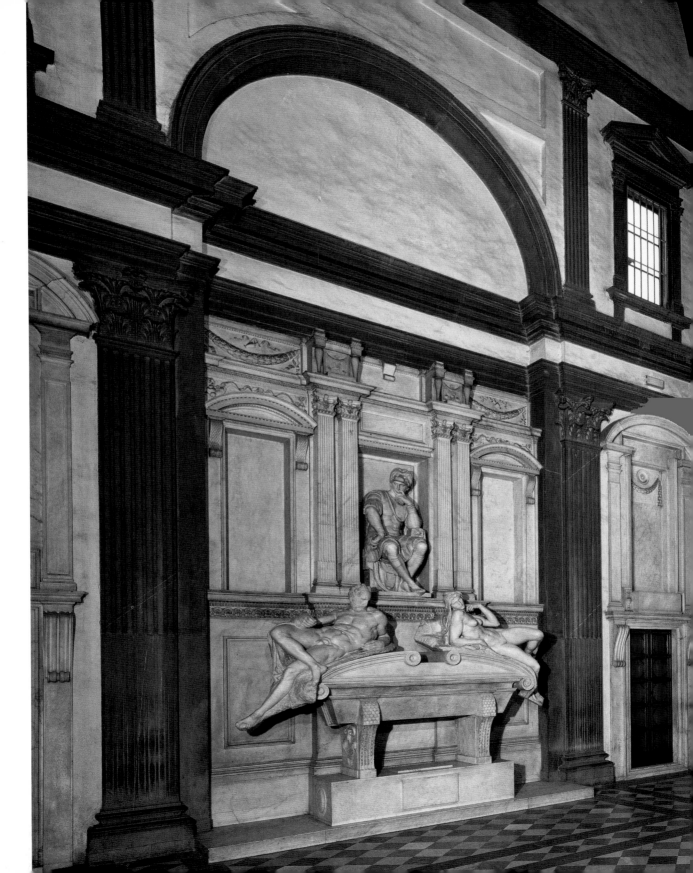

Medici Chapel: the tabernacles weigh heavily on the doors.

End wall with 'perspectively fore-shortened' window.

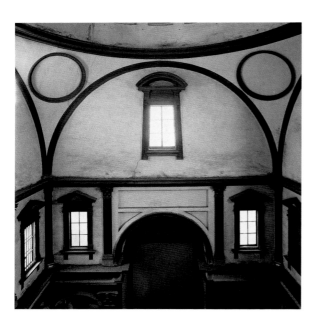

so strongly, as though they might crush the doors below them. The arches of the tabernacles impose themselves so persistently that they seem to be elbowing out the pilasters, while the counter-pressure seems to burst the bounds of the profiles.

In this forced confrontation, Michelangelo does, to some degree, subordinate his design to the structured perfection of Brunelleschi's architecture, but in his tendency towards the dialectical, he also undermines his predecessor's vision with almost blatant aggression. In contrast to the central cube – originally intended to be lavishly ornamented with stucco and painting – the cupola still seems to preserve Brunelleschi's predominant rationality.

Yet even here, Michelangelo pays subversive homage to the pioneer of mathematical central perspective by means of a deliberately 'perspectively foreshortened' window *(lower left)* that further emphasises the height of the room. Once again, we find Michelangelo entering the arena with the spirit of a gladiator bent on sundering the 'bonds and chains' of all that has gone before, as Vasari described: "… and so he did the ornamentation in a composite order, in a style more varied and more original than any other master, ancient or modern, has ever been able to achieve. For the beautiful cornices, capital, bases, doors, tabernacles and tombs were extremely novel, and in them he departed a great deal from the kind of architecture regulated by proportion, order and rule which other artists did according to common usage and following Vitruvius and the works of antiquity but from which Michelangelo wanted to break away."

The sense of tension that is created when a large-scale structure is pressed into a small space came to the fore with ever greater clarity from the 1520s onwards, and became one of the predominant attributes of Michelangelo's art. The pent-up aggression, the potential for violence and release involved in such an emancipatory act, the suffering and simultaneous pleasure in captivity, the yearning for liberation from the constricting shell – these are elements that can be found in various guises throughout all his sculptures *(page 70)* and even in his poetry, from the literal metaphors of imprisonment to the spatial confinement of a figure or an architectural element. There is, for instance, no external necessity whatsoever for the figure of *Leda (page 145)* to fill the picture so completely as to be almost pressed into the frame. Likewise, the Medici dukes and the figure of *Moses (page 140)* seem almost to outgrow their niches. However, as in his sonnets, this confinement and restriction, this sense of hindered movement and suppressed emotion signifies not

only a limitation but also gain. Sigmund Freud interpreted this in a positive light in his essay on Michelangelo's *Moses*: "In this way he has added something new and more than human to the figure of Moses; so that the giant frame with its tremendous physical power becomes only a concrete expression of the highest mental achievement that is possible in a man, that of struggling successfully against an inward passion for the sake of a cause to which he has devoted himself."

In the Biblioteca Laurenziana commissioned by the Medici Pope Clement VII and begun in 1523, it is the massive columns with their 'enormous volume and powerful musculature' that represent this inner transformation. The twelve monolithic giants of the S. Lorenzo façade have returned, doubled in number, but this time in the dark grey sandstone of the local Florentine quarries rather than in white marble. The earlier aura of triumph is gone, but it is not, as so many critics have surmised, a sign of waning self-assurance. Turning all the logic of architectural theory on its head, the columns are now set quite unorthodoxically in deep niches, where they have no load-bearing function, so that the beam running above them seems to leap into the breach. They are set above wall consoles that can surely be seen only in terms of an architectural pun. Yet even these almost ridiculous beard-like elements beneath the columns do not in any way undermine the sovereignty of the giants. Withdrawing them into the niches, out of the room and into the sculptural plane of the wall, does not weaken their impact. Instead, like the figures in a restricted space, it actually intensifies their potential and their expressiveness.

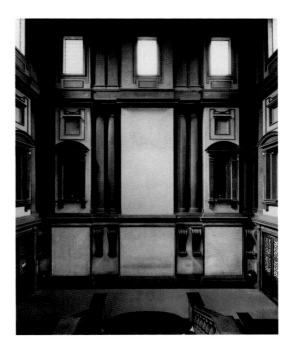

Wall of the vestibule of the Biblioteca Laurenziana.

What had, in the Medici Chapel, been a direct expression of endless conflict between the lost facade and the cubic space, became, in the Biblioteca Laurenziana, a magisterial gesture of deliberate restraint on the one hand and sensory illusion on the other. The ironic play with architectural forms that began there was to take on still greater importance. Whereas before, such barely perceptible elements as the perspectively distorted upper windows had been deployed to continue the canonic architecture *ad absurdum*, there were now far more obvious aspects such as the fluted tabernacle pillars of the main zone, narrowing towards the bottom to emphasise the pressure of the main storey on the empty wall area below. Another innovation, the seemingly anti-rational placement of the colossal order in the second storey, had already been foreshadowed in the compressed lower storey of the S. Lorenzo facade (*page* 112). The logic here is that the elongated reading room of the library with its distinctly rhythmic pilaster alignment continues into the vestibule

Pages 120/121:
One of the world's most beautiful reading rooms: the Biblioteca Laurenziana.

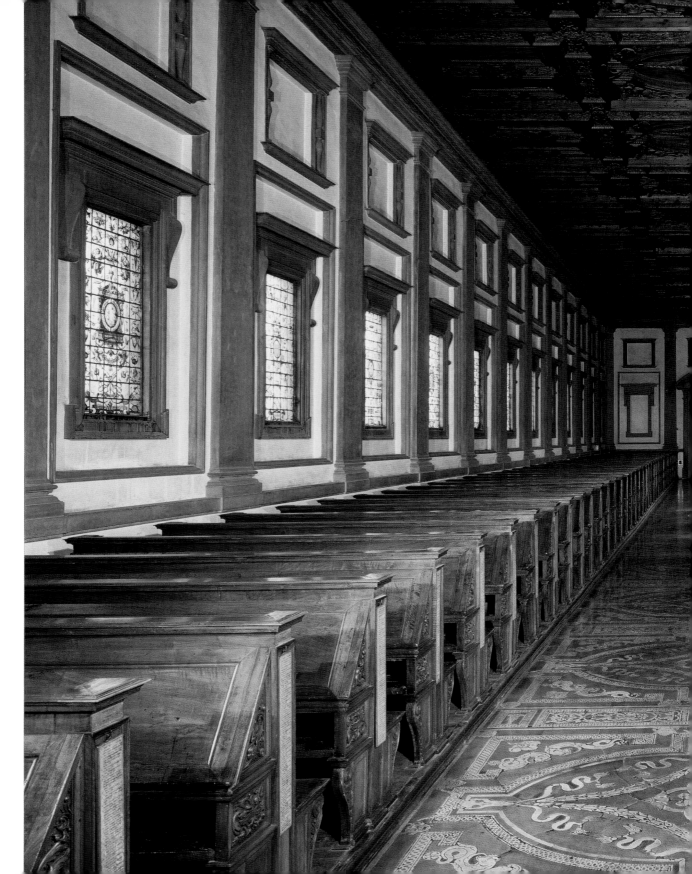

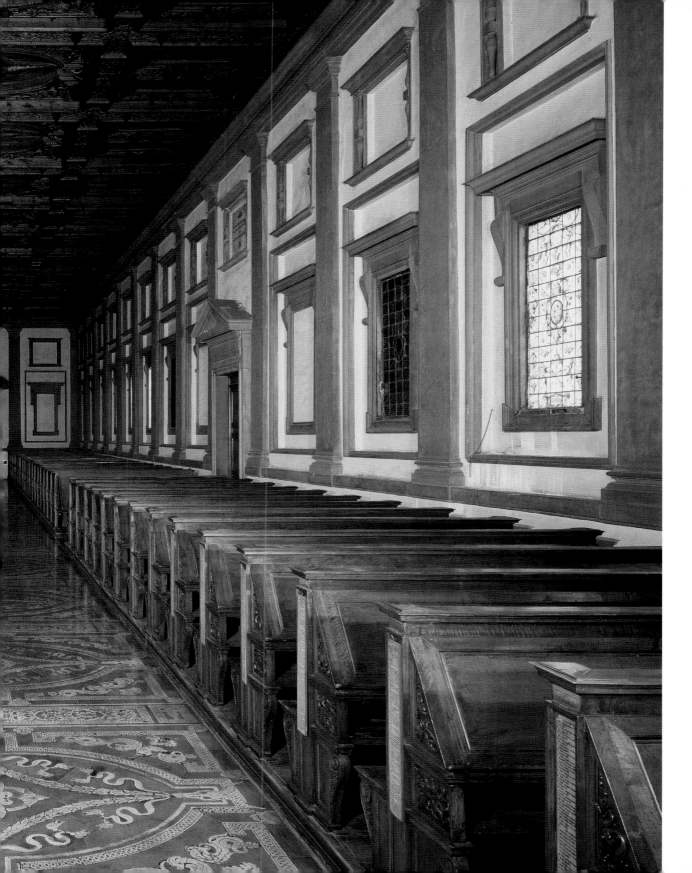

on one and the same level. The base course, which seems more organically developed than tectonically structured, corresponds here to a separate earthly zone in which the *voluta* appear as abstracted Hermes consoles. The Biblioteca Laurenziana, designed throughout by Michelangelo, is the building most faithful to his own plans and at the same time the most important of his architectural works. It is the first purely architectural creation without ostentatious ornamentation. The contract, following on from the facade of S. Lorenzo and the Medici Chapel, was one that Michelangelo accepted with some reluctance, maintaining that architecture was not his craft. And indeed, much of the originality applied in the design is due to this very fact. Michelangelo has transposed the expressive potential of sculpture into abstract forms. In keeping with his artistic temperament and his often anti-classical impulses, Michelangelo has allowed himself considerable license, as mentioned by Vasari, in respect of the accepted canon of architecture. In doing so, he has followed his own creative logic.

Before the Sack of Rome in 1527 brought everything to a halt, Michelangelo had acquired an expressive architectural language that applied an entirely new syntax to the traditional architectural vocabulary. Now, the man who had served as a high-ranking architect in constructing the city fortifications for the short-lived Republic of Florence was able to extend his realm of experience to include strategic spatial planning. By the time he was finally called back to Rome in 1534 to paint the end wall of the Sistine Chapel, he was as accomplished an architect as he was a sculptor and painter. His personal emblem of three disciplines embodied in three intersecting circles, adopted from the Medici *palle*, was translated into an outward form in a papal brief of 1 September, 1535 when Pope Paul III appointed him 'supreme architect, painter and sculptor of the Apostolic Palace'. It heralded a new role: soon Michelangelo was no longer an architect, 'painter or sculptor like a shop-keeper', but had achieved a position in the world of art that was comparable to that of the Pope in religious matters. He was the highest authority in artistic matters. The artist who, until well into his middle years, had drawn his greatest inspiration from the direct handling of the material and from the progress of the construction – as in the case of the *Biblioteca Laurenziana*, for which he did not actually travel to the stone quarries as had previously been his wont – was now becoming the senior authority on architecture in Rome. He made some seminal contributions to architecture with his alterations of existing structures, such as his design for the Capitoline Hill, creating the first self-contained square in early modern urban design. He designed, paved the way, modified – but few of his designs were ever completed. Although he did not actually build any major new edifices, Michelangelo's ideas were to influence the architecture of Rome right through to the seventeenth century. When he was appointed chief architect of St Peter's in 1546 at the age of almost seventy-two, he seemed less than delighted. In spite of the enormous prestige of this position, taking on this rambling building whose plans had been constantly and repeatedly altered over a

View into the cupola of St Peter's. The tambour zone follows Michelangelo's original plans.

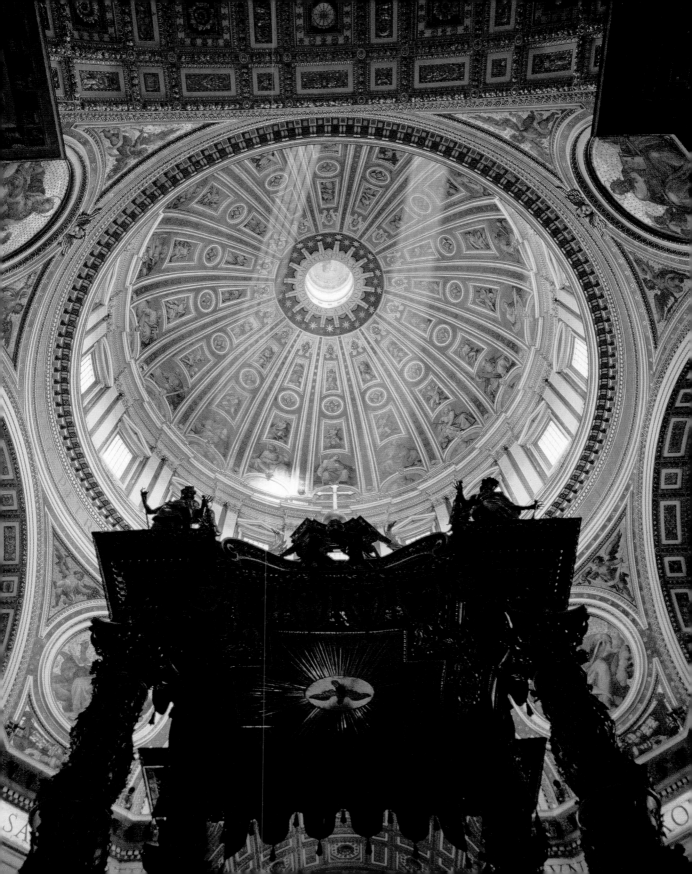

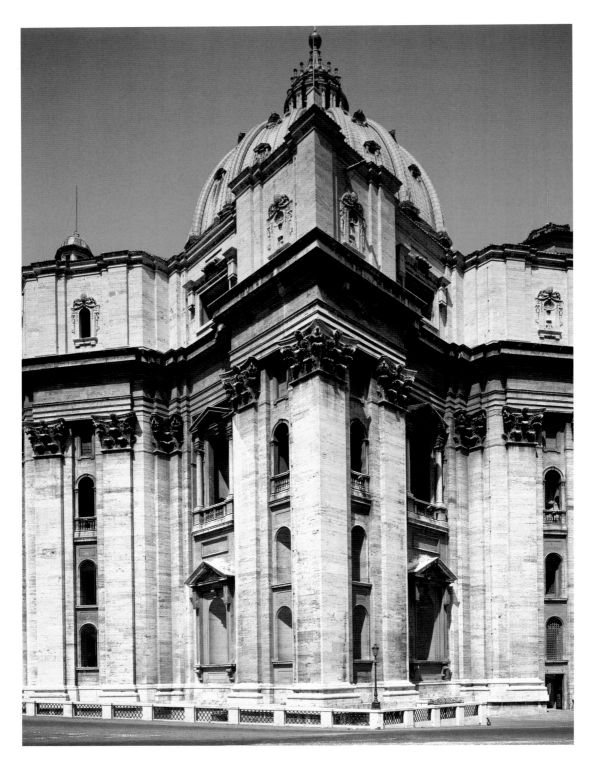

period of some forty years, was a thankless task. Michelangelo adopted Bramate's original floor plan in the form of a Greek cross, reduced it in scale and made the cupola the main focus with the aim of creating a uniform volume out a multiplicity of structural parts. On the exterior, sculpturally graduated colossal pilasters serve to pull the building together visually and emphasise its verticality. The relief of the structure completely dissolves the flat wall. In St Peter's, Michelangelo also reiterated a key concept of his early architectural designs: the building as sculpture. The dominant pilasters lend the building a vertical dynamic that flows through the double columns of the tambour into the ribs of the cupola. It is here, in the column pairs of the tambour, that the white giants of the lost S. Lorenzo facade appear triumphant at last, radiating their force throughout the world. Towards the end of his life, Michelangelo struggled determinedly against the *non-finito* of his many unfinished works – an almost Sisyphean task, given the sheer scale of the St. Peter's project. At least he lived to see the tambour completed. In spite of the enormous temptation to return to his home city, where flattering offers and honours awaited him, he

remained in Rome. Until the very end, he remained at the helm of the project to which he had been called by God and the Pope. He replied to Vasari's repeated invitations: "So to abandon it at this stage would mean the shameful waste of all the labours I have undertaken for the love of God during these ten years. … In conclusion, to make you understand what would happen if I abandoned the building and left Rome: first, I would make many thieves happy, and I would be responsible for its ruin, and perhaps for closing it down forever."

Pages 124/125:
Exterior view of the apse looking towards the cupola of St Peter's.

Page 126:
The hand of *David*, detail of the marble statue of 1501–04.

Biography and List of Works

POLITICAL AND CULTURAL
LIFE IN ITALY

1469 Lorenzo de' Medici (Il Magnifico) comes to power. It is the dawn of 'The Golden Age' in Florence when art and literature flourish.
1470–1490 Lorenzo de' Medici and the humanist Marsilio Ficino attract a circle of scholars and Lorenzo himself becomes Italy's leading poet.
1478 The Pazzi family of Florence conspires with those close to the Pope against Lorenzo de' Medici. In an attempt to assassinate him in the cathedral of Florence, Lorenzo's younger brother Giuliano is killed instead.
1480 Lorenzo negotiates peace between Florence, Rome and Naples.
1482 Leonardo da Vinci goes to the court of Milan, where he stays until 1499.
1483 Raphael is born in Urbino.

1475–1488

THE LIFE AND WORK OF
MICHELANGELO

EARLY YEARS

Michelangelo was born on 6 March **1475** in the mountain village of Caprese in the Val Tibertino at the outer boundaries of the Republic of Florence. He was the second of five sons born to Lodovico di Lionardo di Buonarroti Simon, scion of a family of merchants, money-changers and bankers documented since the twelfth century who, as members of the Republican Guelph party, had always held important posts in public office. The family's economic decline began in the days of Michelangelo's grandfather. His father and his uncle lived modestly, deriving their income from an estate in Settignano and from some minor official posts.

Ludovico's term in office as mayor of Caprese ended shortly after Michelangelo's birth. The family returned to Florence. Michelangelo spent the first years of his life with a family of stone-masons in rural Settignano, cared for by a wet-nurse. His mother died in 1481.

Some time between **1482 and 1488** – the date is not precisely documented – Michelangelo returned to Florence to study at the Latin school of one Francesco da Urbino. His father and uncle had hoped that he would carry on the family tradition by becoming an upright public servant, but Michelangelo preferred to spend his time in the workshop of the painter Domenico Ghirlandaio, where his friend Francesco Granacci worked. Michelangelo's father seems to have come to terms eventually with the further social decline of his family, as represented by his son's decision to become an artisan, for on 1 April **1488** Lodovico agreed to his entering a three-year apprenticeship with the Ghirlandaio brothers.

Group of three men (possibly after Masaccio's *Sagra del Carmine*), *c.* 1496, pen and ink, 29 x 19.7 cm, Graphische Sammlung Albertina, Vienna.

Two figures (after Giotto), *c.* 1490, pen and ink, 32 x 19.7 cm, Cabinet des Dessins, Musée du Louvre, Paris.

St Peter (after Masaccio's *Tribute Money*), *c.* 1489–90, pen and ink and red chalk, 31 x 18.5 cm, Graphische Sammlung München, Munich.

1489 Filippo Strozzi has the Palazzo Strozzi built in Florence by Benedetto da Majano. Flippino Lippi begins work on the frescoes in S. Maria sopra Minerva in Rome.

1490 Ghirlandaio begins his fresco cycle of scenes from the *Life of the Virgin* and *Life of John the Baptist* in S. Maria Novella in Florence.

1491 Presumed year of the birth of Ignatius Loyola, founder of the Jesuit Order.

1489

1490–1492

AT THE MEDICI COURT
In **1489** Michelangelo left the Ghirlandaio workshop without completing his apprenticeship there and moved with Granacci to the Gardens of San Marco, where the Donatello student Bertoldo di Giovanni ran a kind of free art school in the antiquities collection of Lorenzo de' Medici. The students honed their skills by copying the frescoes of older masters such as Giotto and Masaccio, and by studying the sculptures and antiquities in the Medici collection. After some initial experiments in clay, Michelangelo turned his attention to working in stone.

With his *Head of an Old Faun* after a classical model, Michelangelo's talent came to the attention of Lorenzo il Magnifico. From **1490–1492** Michelangelo lived as one of the family in the house of the Medici, receiving a scholarship and a humanist education. Whereas his first documented work, the *Madonna of*

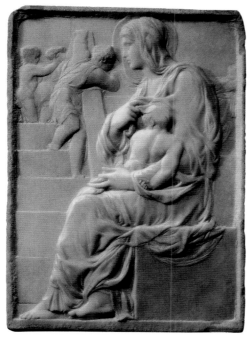

Madonna of the Steps, c. 1492, marble, 55.5 x 40 cm,
Casa Buonarroti, Florence.

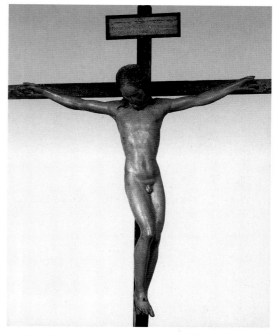

Crucifix, c. 1492/1593, polychromed wood, 135 x 135 cm,
Casa Buonarroti, Florence.

"Never have more beautiful things been
created in our century than your works."

Benvenuto Cellini in a poem to Michelangelo

1492 Death of Piero della Francesca, leading
Tuscan painter of the quattrocento.
Death of Lorenzo il Magnifico.

1494 Leonardo da Vinci founds a school of
painting in Milan.
The Medici are driven out of Florence. The
Dominican preacher Girolamo Savonarola

1492

1494

the Steps, is still clearly influenced by
Donatello, the *Battle of the Centaurs* created
shortly afterwards conveys a distinct aware-
ness of late Roman reliefs and the literary
tradition of antiquity nurtured by Angelo
Poliziano.

The paradisiacal years of creative freedom in
an intellectual setting, which Michelangelo
would later describe as the happiest years of
his life, ended with the death of his patron
on 9 April **1492**. He returned to the house of
his father, but continued to work for Loren-
zo's successor Piero. In **1494** he completed a

possibly over-life-size statue of *Hercules*,
which was later exported to France, and
which has been lost since the eighteenth
century. Michelangelo undertook anatomical
studies in the hospital of the priory of Santo
Spirito, and expressed his gratitude to the
prior for this privilege by carving a wooden

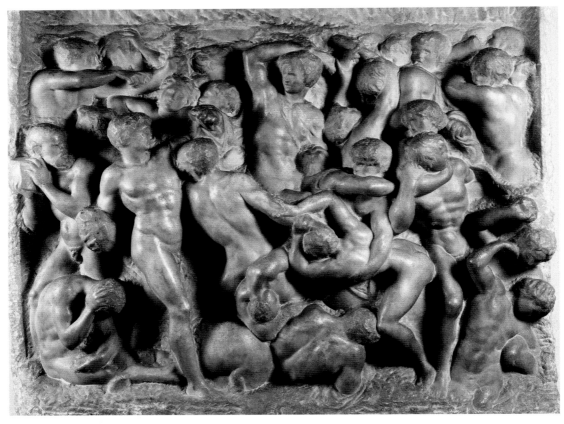

Battle of the Centaurs, 1492, marble, 84.5 x 90.5, Casa Buonarroti, Florence.

founds a 'divine state' in Florence and sets up a republican regime (*governo largo*) that involves the middle classes in politics on an equal basis.

France under Charles VII invades Italy in alliance with Ludovico Sforza, Duke of Milan.

1494

1494–1495

Crucifix, the whereabouts of which are unknown today. A crucifix long attributed to Michelangelo is probably not by him at all. Even before the banishment of Piero de' Medici in October 1491, Michelangelo fled to Venice via Bologna before the advancing French army. He then returned to Bologna,

where he stayed for about a year as a guest in the palace of Gianfrancesco Aldovrandi, for whom he created three small marble statues for one of the great masterpieces of Northern Italian sculpture, the Shrine of St Dominic in S. Domenico Maggiore: the figures of *St Proculus* and *St Petronius*, and a

kneeling *Angel* bearing a candelabrum. The figures and reliefs by Jacopo della Quercia in the Cathedral of Bologna, dating from the second quarter of the century, are the second major non-classical source for Michelangelo's sculpture apart from the work of Donatello.

Angel with Candelabrum, 1494–95, marble, 51.5 cm high, San Domenico, Bologna.

"… Michelangelo, standing always firmly rooted in his profound understanding of his art, has shown those who can understand how they should achieve perfection."

Giorgio Vasari

St Proculus, 1494-1495, marble, 58.5 cm high, San Domenico, Bologna.

St Petronius, 1494–95, marble, 64 cm high, San Domenico, Bologna.

1495 Milan, Venice and Rome are defeated at the Battle of Fornovo by Charles VIII , who had designs on Naples.

1495 Savonarola excommunicated.

1495

1496

Towards the end of **1495** the artist returned to Florence and entered the service of the Republican Medici who had by now come to power. A figure of the young *John the Baptist* and a *Sleeping Cupid* he created for Lorenzo di Pierfrancesco de' Medici are now lost. Lorenzo put the *Cupid* on the Roman market as an original work of antiquity. Although the scam was uncovered, the affair surrounding the counterfeit *Cupid* was to have a happy ending for Michelangelo.

EARLY YEARS IN ROME
In **1496** Cardinal Riario, an influential figure, called Michelangelo to Rome, showed him through his collection of sculptures and commissioned him to create the first free-standing life-size sculpture in the round that Rome had seen since the days of antiquity.

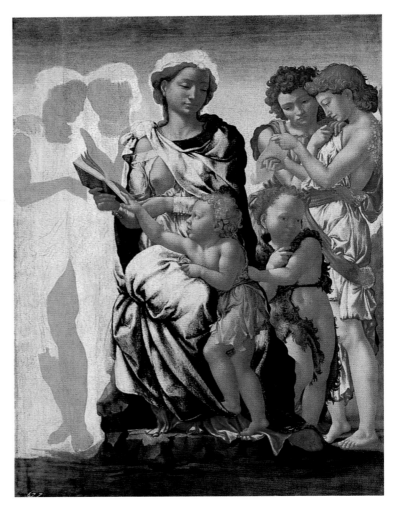

Manchester Madonna,
c. 1497, tempera on
canvas, 104.5 x 77 cm,
National Gallery, London.

Bacchus, 1496–97, 184 cm high, Museo Nazionale
del Bargello, Florence.

1497 Leonardo finishes his fresco of *The Last Supper* in the refectory of the Dominican monastery of S. Maria delle Grazie in Milan.

1497

In **1497**, Riaro rejected Michelangelo's shockingly realistic figure of a most unwholesomely inebriated *Bacchus* – further disfigured by an obvious vein of marble. In the cradle of the classical world, Michelangelo had failed in his emulation of antiquity. The banker Jacopo Galli, in whose house

Michelangelo lived and worked, accepted the *Bacchus* and commissioned a further mythological figure (*Apollo* or *Cupid*). He made an effort to keep Michelangelo's head above water by arranging further commissions – mostly for panel paintings, such as the *Manchester Madonna.*

1498 Savonarola executed.
Death of Charles VIII. Louis XII of the House of Orléans becomes king of France.

1498

Galli repeatedly appears in the contracts he himself mediated as a guarantor for the artist. In a contract dated **1498** he personally guarantees that Michelangelo will create "the most beautiful work in Rome today" for the tomb of Cardinal Jean Bilhères de Lagraulas, French envoy to the Vatican.

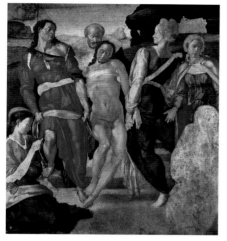

The Entombment, 1500/01, oil on wood, 161.7 x 149.9 cm, National Gallery, London.

"It is certainly a miracle that a formless block of stone could ever have been reduced to a perfection that nature is scarcely able to create in the flesh."

Giorgio Vasari writing about Michelangelo's *Pietà*

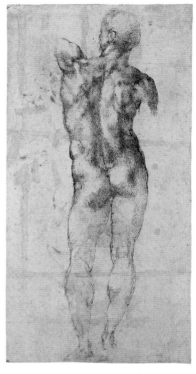

Male Nude, c. 1504-1506, pen and ink drawing, 37.9 x 18.7 cm, Albertina, Vienna.

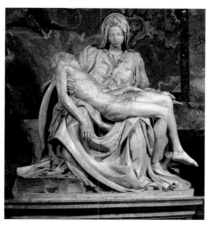

Pietà, 1499–1500, marble, 174 cm high, St Peter's, The Vatican.

1499 Louis XII conquers Milan and Genoa, ending Sforza's rule.	**1500** In Venice, Ottavio dei Petrucci is the first to print music using movable type.	**1501** Leonardo is the first to describe the camera obscura.
1499	**1500**	**1501**
In order to avoid having another work marred, like the *Bacchus*, by flawed marble, Michelangelo now began selecting his stone with the utmost care. He spent nine months on the selection and transportation of marble from Carrara. Then, within the space of a year, up to late **1499** or early **1500**,	he completed the *Pietà* that was to seal his fame as a sculptor. Michelangelo abandoned another Galli-mediated contract for an altarpiece of the *Entombment* and devoted himself entirely to sculpture instead.	STATE ARTIST OF THE REPUBLIC OF FLORENCE In March **1501** Michelangelo left Rome to provide 15 figures for the Piccolomini Altar in Siena Cathedral – also commissioned through Galli. This work, too, was set aside in favour of a more important project in Flo-

St Paul, 1501–04, marble, 127 cm high, Piccolomini Altar, Duomo, Siena.

St Peter, 1501–04, marble, 124 cm high, Piccolomini Altar, Duomo, Siena.

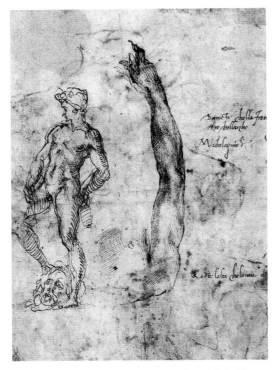

Drawing for a bronze *David* and for the arm of a marble David, 1501–02, pen and ink, 26.5 x 18.7 cm, Musée du Louvre, Paris.

Pope Gregor the Great, 1501–04, marble, 136 cm high, Piccolomini Altar, Duomo, Siena.

Pope Pious I, 1501–04, marble, 134 cm high, Piccolomini Altar, Duomo, Siena.

1502 Titian paints his *Gypsy Madonna*. Aldus Manutius develops an italic typeface in Venice.

1503 Death of Pope Alexander VI. Julius II becomes Pope.

1502 1503

rence. In August, he had been commissioned to create, within two years, a colossal statue of *David* out of a huge rough-hewn marble block that had originally been earmarked for one of the cathedral buttresses, but had been badly botched. The board of works of the cathedral, having given the marble block

to the Republic, was to be compensated with 12 figures of the Apostles for the interior of the cathedral. According to the contract dated 1503, Michelangelo was to provide one figure per annum. The only surviving work is the unfinished statue of *Saint Matthew*. By **1502** the resounding success of the statue

of *David* was already plainly evident. Michelangelo was asked to cast a bronze *David* after Donatello as an ambassadorial gift for Pierre de Rohan, a protégé of the King of France. In the end, it was completed by another artist and is now lost. By the summer of **1503** the gigantic marble figure

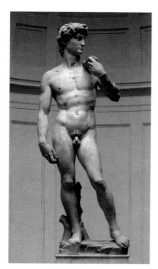

David, 1501–04, marble, 410 cm,
Galleria dell'Accademia, Florence.

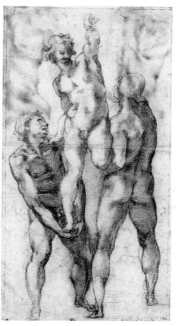

Group of three figures for the *Battle of
Cascina*, *c.* 1504, pencil and pen and ink,
33 x 17.5 cm, Cabinet des dessins, Musée du
Louvre, Paris.

St Matthew, *c.* 1503–05, marble, 271 cm high,
Galleria dell'Accademia, Florence.

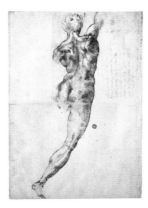

Life study for the *Battle of Cascina*,
c. 1504, pen and ink and pencil,
40.8 x 28.4 cm, Casa Buonarroti,
Florence.

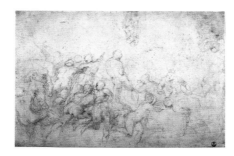

Sketch after the cartoon for
Bathing Soldiers; two studies
for a *Ganymede*, *c.* 1530, chalk
over metal pen, 23.5 x 35.5,
Gabinetto dei Disegni e delle
Stampe, Florence.

1504 Raphael comes to Florence.
Death of Filippino Lippi.

1504

was almost completed. After much debate, it
was decided that it should be placed on the
Piazza Signoria. Installed there in May **1504**,
it came to symbolise the civic virtues of a
free citizenry.

In the politically stable heyday of the Repub-
lic, the *gonfalionere* Soderini, who favoured
Michelangelo, ensured that he received fur-
ther public commissions. In the summer of
1504 Michelangelo was commissioned to
fresco the Council Hall, the Sala del Gran
Consiglio, of the Palazzo Vecchio with a por-
trayal of the *Battle of Cascina* — in direct
competition with the monumental *Battle of
Anghiari* by his arch-rival Leonardo. Both
artists failed to take the project beyond the
grand design cartoons. Leonardo interrupted
his work on the frescoes on technical
grounds, Michelangelo because of a calling
to Rome.

"I would rather forgo all happiness on earth
than to have come into this world without
having seen you and your works."

Agnolo Doni in a letter to Michelangelo

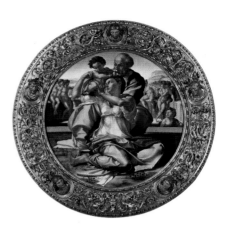

Tondo Doni, 1503–04, tempera on wood, 91 x 80 cm,
Galleria degli Uffizi, Florence.

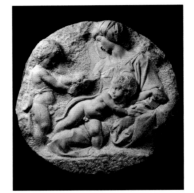

Tondo Taddei, c. 1504–06, marble,
109 x 104 cm, Royal Academy of Arts,
London.

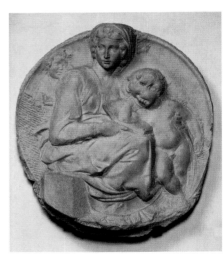

St Anne, the Virgin and Child, undated, black
chalk, 32.5 x 26 cm, Musée du Louvre, Paris.

Tondo Pitti, c. 1503, marble,
Museo Nazionale del Bargello,
Florence.

1505 In Florence, Raphael paints his
Madonna of the Meadow.

1504–1506	1505

In the years **1504–1506**, apart from a number
of public works, Michelangelo created the
Bruges Madonna for the Flemish merchant
Alexandre de Mouscron, two marble reliefs
of the *Virgin and Child* for Taddeo Taddei and
Bartolomeo Pitti, now widely known as the
Taddei Tondo and the *Pitti Tondo*, respective-
ly, and the only surviving completed panel
painting by Michelangelo, the *Holy Family*
(also known as the *Doni Tondo*) for Angelo
Doni (1506). Soderini requested a monumen-
tal *Hercules* by Michelangelo as a pendant
to the *David*, but the project was delayed
beyond the end of the Republic. Given his
fame, it was inevitable that Michelangelo
should eventually be drawn into papal
circles.

IN THE SERVICE OF JULIUS II
In March **1505** Michelangelo was summoned
to the Vatican, where Pope Julius II commis-

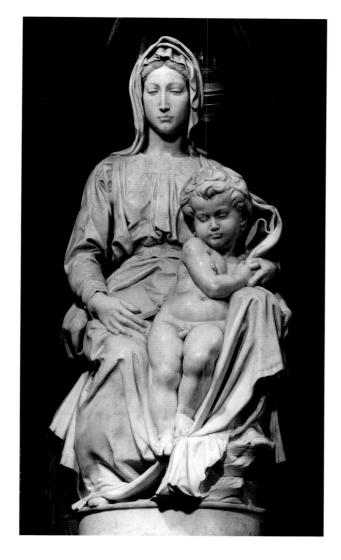

"The best of artists hath no thought to show,
which the rough stone in its superfluous shell
doth not include;
to break the marble spell
is all the hand that serves the brain can do."

Giorgio Vasari

Bruges Madonna, c. 1504–06, marble,
94 cm high, Onze-Lieve Vrouw, Bruges.

1506 Bramante begins work on the new
Basilica of St Peter in Rome.
Leonardo paints the *Mona Lisa.*
Andrea Mantegna dies in Mantua.

1506–1516 Leonardo works again (with inter-
ruptions) at the Milanese court.

1506

sioned him to design a huge funerary monu-
ment. Once the design had been approved
he went to Carrara to select the marble, and
stayed there from April until the end of the
year.
In January **1506**, Michelangelo was one of
the first to see the Late Hellenistic *Laocöön*

Group at its excavation site. Exhilarated by
his major contract for the *Tomb of Julius II*,
he purchased his first country estate near
Florence in January. When the delivery of the
marble blocks was delayed by inclement
weather, the Pope lost patience and changed
his mind about the tomb, concentrating

instead on rebuilding St Peter's Basilica. Furi-
ous at this change of plans and at his treat-
ment by the Pope, who did not even appear
willing to reimburse his expenses, Michelan-
gelo hastily left the Vatican on 17 April. It was
not until November, under considerable
pressure from the Republic of Florence, that

Separation of Light from Darkness, Sistine Chapel Ceiling, 1511, Capella Sistina, Musei Vaticani, Rome.

"What spirit is so empty and blind that it cannot recognise the fact that the foot is more noble than the shoe, and the skin more beautiful than the garment with which it is clothed?"

Michelangelo

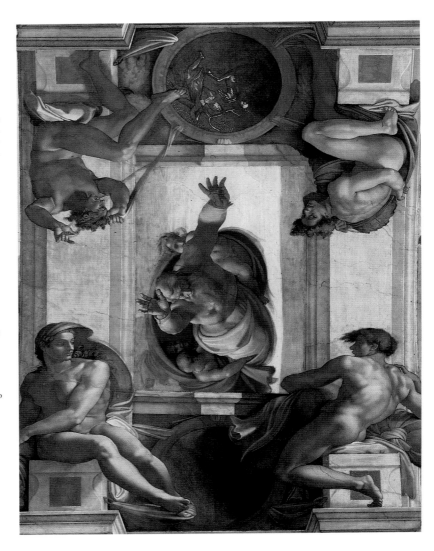

The Emperor, Pope Julius II, France, Naples and other Italian states form an alliance against Venice in 1508 in the League of Cambrai that strains the political and economic power of Venice to the limit.
1508 Raphael begins painting the *Stanze* at the Vatican.

1509 Venice loses its entire *terraferma* territories, regaining them by 1517 through diplomacy.

1507 1508

there was a reconciliation between Michelangelo and the Pope in Bologna.

In **1507** Michelangelo was asked to create an over-life-size bronze *Statue of Julius II* for the portal of S. Petronio in Bologna. This was his first work cast in bronze, and the task was

fraught with difficulty, taking him the best part of a year to complete.
Shortly after completing the bronze statue in February **1508,** (it was destroyed just three years later in an uprising) Michelangelo was called to Rome. However, instead of being asked to make the Julian monument, as he

had hoped, he was now required to decorate the *Ceiling of the Sistine Chapel.* After much resistance, he reluctantly agreed. With the originally simple design embellished into an extremely complex one, the project was jeopardised both by the technical difficulties involved in the unfamiliar task of fresco

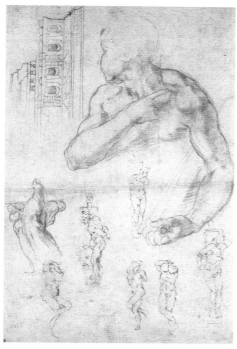

Studies for the Sistine Chapel with pen and ink sketches of the captives for the Julian monument, *c.* 1513, red chalk and pen and ink, 28.5 x 19.5 cm, Ashmolean Museum, Oxford.

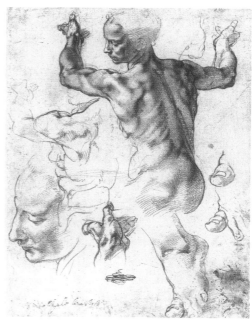

Studies for the Libyan Sibyl, c. 1510, red chalk on paper, Metropolitan Museum of Art, New York, from the estate of Joseph Pulitzer.

"This is the true way of drawing, by which to become an accomplished painter, as evinced by the extraordinary Michelangelo Buonarroti, who as I believe, achieved so much in painting for no other reason than the fact that he was a most perfect sculptor and had more knowledge of that art than any other in our time."

Johann Wolfgang von Goethe

c. **1510** Leonardo paints his *Virgin and Child with St Anne* (Paris, Louvre).

1512 Spanish troops overthrow the government and end the Republic of Florence. The Medici return to the city.

1513 Giovanni de' Medici becomes Pope Leo X, the first Medici Pope.
1514 Niccolò Macchiavelli writes his political treatise *Il Principe.*

1509–1510	1511–1513	1516

painting and by the discrepancy between the ambitious concept and his own painterly skills.
In the spring of **1509** the Pope insisted that he continue the project. By the summer of **1510** the first half of the *Sistine Chapel Ceiling* was virtually completed, but papal cam-

paigns and the Pope's ill health meant that it could not be unveiled until 15 August **1511**. Once the scaffolding had been re-erected, the second half of the ceiling was completed much more swiftly, and was solemnly inaugurated on the eve of All Hallows **1512**. In February **1513** Julius II died. Michelangelo

entered into a new contract with his successor to create the Julian monument, now in the form of a wall tomb, and worked on this project until **1516**. It was during this period that he created the so-called *Rebellious Slave*, the *Dying Slave* and the figure of *Moses*, which was completed later. Michelan-

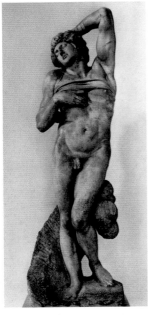

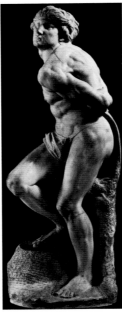

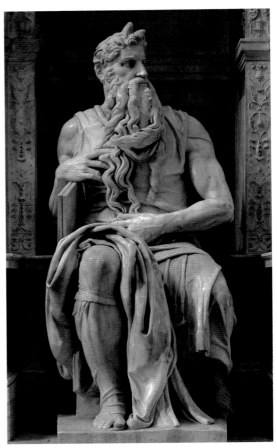

Dying Slave, c. 1513, marble, 229 cm high, Musée du Louvre, Paris.

Rebellious Slave, 1513–16, Musée du Louvre, Paris.

Moses, the Tomb of Julius II, c. 1513, marble, 235 cm high, S. Pietro in Vincoli, Rome.

1515 Raphael is appointed chief architect of St Peter's.

1516 Leonardo moves to France at the invitation of Francois I.
Titian paints his *Venus de Urbino*.

Raphael is appointed director of excavations of antiquities in Rome.

1516

gelo purchased the house at Macel de' Corvi where he was to live until his death, bar a few years in Florence, and set up his sculpture studio. By this time, the Medici were back in power and the new Pope Leo X was a son of Lorenzo de' Medici whom Michelangelo had known since his youth.

THE GREAT MEDICI PROJECTS AND THE REPUBLICAN INTERMEZZO
Although they had known each other since their youth, Michelangelo was not the first choice of artist for the new Pope following the Medici return to power. He exercised his influence in the Vatican by way of an indirect

rivalry with Raphael through collaboration with the Venetian painter Sebastiano del Piombo, for whom he continued to supply designs for frescoes and paintings right into the 1530s. Michelangelo also had other works completed by students, such as *Risen Christ* for S. Maria sopra Minerva.

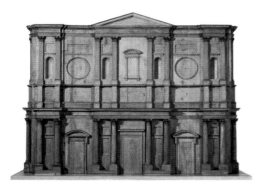

Model for the facade of S. Lorenzo, c. 1518, wood,
216 x 283 x 50 cm, Casa Buonarroti, Florence.

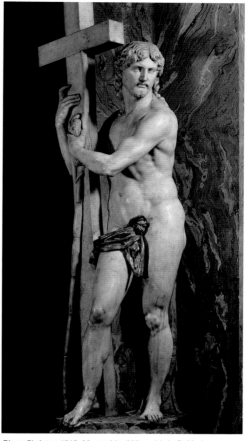

Risen Christ, c. 1518–20, marble, 205 cm high. S. Maria sopra
Minerva, Rome.

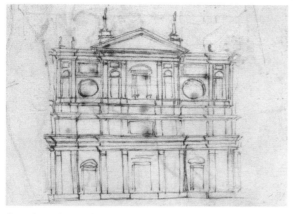

Study for the facade of S. Lorenzo, c. 1518, black and red chalk,
14 x 18 cm, Casa Buonarroti, Florence.

1517 Coffee arrives in Europe.

1516

1517–1518

It was not until **1516,** in the course of the restructuring of the Medici territory, that he became more active in asserting his status as an artist. In spite of a new contract concluded on 8 July 1516 for a third version of the Julian monument, Michelangelo also took on the entire planning of the *Façade of S. Lorenzo,* for which he had originally been asked only to provide the sculptural ornamentation. It was some time before the sceptical Pope and his cousin Cardinal Giulio de' Medici were actually persuaded of Michelangelo's abilities as an architect.

The definitive contract for the façade was not concluded until 19 January **1518.** Michelangelo disbanded his household in Rome and even had the marble blocks for the Julian monument sent to Florence.

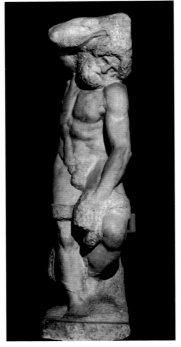

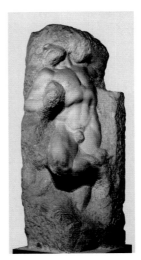

Waking Slave, after 1519, marble, 267 cm high, Galleria dell' Accademia, Florence.

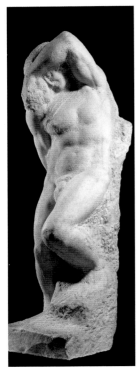

Bearded Slave, after 1519, marble, 263 cm high, Galleria dell' Accademia, Florence.

> "Thus all artists are under a great and permanent obligation to Michelangelo, seeing that he broke the bonds and chains that had previously confined them to the creation of traditional forms."
>
> Giorgio Vasari

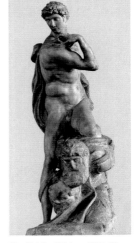

The Spirit of Victory, 1519–25, marble, 261 cm high, Palazzo Vecchio, Florence.

Young Slave, c. 1519, marble, 256 cm high, Galleria dell' Accademia, Florence.

1518 Ariosto becomes director of the court theatre at Ferrara, staging performances that go down in theatrical history.

1519 Death of Leonardo da Vinci at Cloux, near Amboise.
1520 Death of Raphael in Rome, during an outbreak of plague.

1521 End of the Academia Platonica founded in Florence in 1459 by Cosimo de Medici.

1518–1519	1520	1521

From **1519** onwards he worked on the figures of the *Captive* and *Victory*, which are still in the Accademia in Florence today.

After several years of enormous endeavour and extreme technical difficulty in quarrying marble on a scale unparalleled since antiqui-

ty, Leo X interrupted the construction work in March **1520**. Michelangelo's energies were now devoted entirely to the *New Sacristy*, or *Medici Chapel*, in S. Lorenzo intended as a pendant to Brunelleschi's *Old Sacristy*. Michelangelo drew up the architectural plans and envisaged executing most of the sculp-

tural ornamentation himself. In **1521** he visited the stone quarries one last time to select the material for this project personally. During these years in Florence, he increasingly took on the role of a general contractor and project manager delegating many tasks.

Interior of the Medici Chapel, 1520–34, S. Lorenzo, Florence.

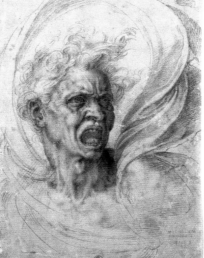

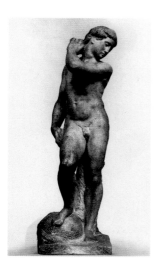

The Resurrection, c. 1530, red chalk, 15.2 x 17.1 cm, Département des Arts Graphiques, Musée du Louvre, Paris.

Study of a clean-shaven man screaming, also known as The Damned, c. 1525, black ink, 35.7 x 25.1 cm, Galleria degli Uffizi, Florence.

Apollo, also known as David, c. 1525–30, marble, 146 cm high, Museo Nazionale del Bargello, Florence.

1523 A cousin of Leo X becomes Pope Clement VII and supports the French in Italy.

1525 Emperor Charles V drives the French out of Italy at the Battle of Pavia, securing Habsburg rule.

1526 End of the first war for Milan between Charles V and Francois I.

1523

1526–1527

Pope Clement VII, the former Florentine Cardinal Giulio de' Medici, who was a cousin of Leo X, was enthroned in November **1523**. He began his term of office by commissioning Michelangelo to undertake a new and entirely architectural project: the *Bibliotheca Laurenziana*. Designed and constructed over the

following three years in close consultation with the Pope, the library at S. Lorenzo is the one architectural project realised most fully in accordance with Michelangelo's own designs. By the end of **1526** it was largely completed, but for the stairway. At the same time, Michelangelo tried to make headway

on the sculptures for the *Medici Chapel* and for the impatiently waiting heirs of the *Julius Tomb*.

Following the Sack of Rome the Medici were cast from power in Florence for the third time in May **1527**. In the uprising, the statue

Design for the fortifications of Porta al Prato d'Ognisanti, 1529, pen and ink with traces of red chalk, 41 x 57 cm, Casa Buonarroti, Florence.

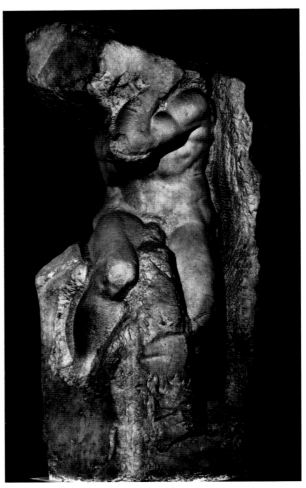

Atlas Slave, c. 1530–34, marble, 277 cm high, Galleria dell' Accademia, Florence.

1527–1528	1529	1530
1527 Sacco di Roma: the Sack of Rome by German and Spanish troops under Charles V. The Medici are once again driven out of Florence.	**1529** Giovanni Battista da Monte introduces practical medical training in Padua, with students actually visiting hospitals. **1529–30** Charles V's troops in Florence.	**1530** Charles V crowned Emperor at Bologna. The Medici are reinstated in Florence.

of *David* was damaged. Michelangelo quietly continued working on the sculptures for the *Medici Chapel* and the *Julius Tomb*, but soon overtly took the side of the Republic. From **1528,** following the example of Leonardo, he became instrumental in modernising and extending the city's fortifications. On. 6 April

1529 he was appointed Architect of Defences. When the imperial army, now backed by the Pope, marched on Florence in September, he fled to Venice, fearing a possible conspiracy. He even contemplated emigrating to the French court of François I. However, a letter from the Signoria assuring

him of unhindered freedom of movement persuaded him to return in November.

In August **1530** the Florentine Republic capitulated before Emperor Charles V, who handed the city over to papal rule. Michelangelo went into hiding for a time, but unlike other

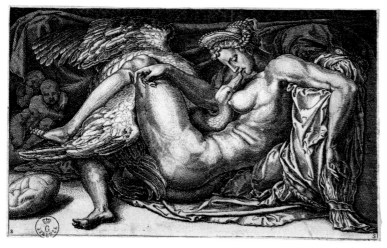

Leda and the Swan, c. 1545, engraving by Etienne Delaune after the painting by Michelangelo.

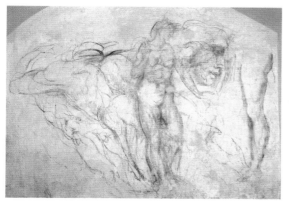

Study of allegorical figures for the Medici tombs, c. 1528–30, charcoal, Medici Chapel, S. Lorenzo, Florence.

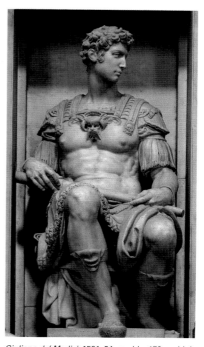

Giuliano de' Medici, 1521–34, marble, 173 cm high, Medici Chapel, S. Lorenzo, Florence.

1531 The appearance of Halley's comet fuels end-of-the-world prophecies.

1532 Macchiavelli's *Il Principe* published. Correggio paints *Leda and the Swan*.

1530	1531	1532

officials of the Signoria, he was pardoned by Clement VII subject to the proviso that he would continue work on the *Medici Chapel*. In the autumn of 1530 Michelangelo completed his painting of *Leda and the Swan* for Duke Alfsonso d'Este of Ferrara, but then refused to hand it over. He began work on

the marble statue of *Apollo* (or *Bacchus*) for Baccio Valori, the papal envoy in Florence.

In November **1531** a papal *breve* was issued forbidding Michelangelo to work on any other project apart from the *Medici Chapel* and the *Julius Tomb*, under threat of excommuni-

cation. By 1534 the figures of the two *Medici Dukes* were finished and the allegorical personifications of time, *Dawn* and *Dusk, Day* and *Night* were installed in the chapel, though not completely finished.
On 29 April **1532**, after lengthy negotiation, a new contract was concluded with the heirs

"And what can I say of the Night, a statue not only rare but unique? Who has ever seen a sculpture of any period, ancient or modern, to compare with this? … And she may well represent the Night that covers in darkness all those who for some time thought, I will not say surpass, but even to equal Michelangelo in sculpture and design."

Giorgio Vasari

Tomb of Giuliano de' Medici, grotesque representing Night, 1521–34, marble, Medici Chapel, S. Lorenzo, Florence.

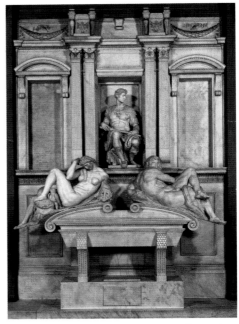

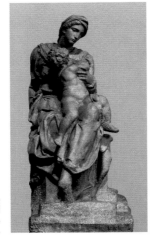

Medici Madonna, 1521–34, marble, 226 cm high, Medici Chapel, S. Lorenzo, Florence.

Tomb of Giuliano de' Medici with the reclining figures of Night and Day, 1521–34, marble, 630 x 420 cm, Medici Chapel, S. Lorenzo, Florence.

1533 Titian paints his *Portrait of Charles V.*

1534 Francesco Guicciardini begins work on the *Storia d'Italia*, published from 1561 onwards.

Loyola founds the *Societas Jesu*, which becomes the most important force in the Counter-Reformation.

1533 1534

to reduce the sculptural ornamentation of the Julian monument to a total of 11 large figures (5 of them by Michelangelo) and to have it installed in S. Pietro in Vincoli. Michelangelo had to repay a considerable sum. He travelled to Rome, where he met the young aristocrat Tommaso de' Cavalieri.

From **1532–1534** he travelled between Rome and Florence, working alternately on the *Julius Tomb* and the *Medici Chapel.* Im June **1534** Michelangelo's father died at the age of 90. In September Michelangelo settled permanently in Rome. When he closed the doors of his workshop on the Via

Mozza in Florence for the very last time on 20 September, he left behind, among the countless blocks of marble and half-finished works, the figure of the *Medici Madonna* which had not yet been installed as well as original size models for the figures of *River Gods* intended to adorn the foot of the sar-

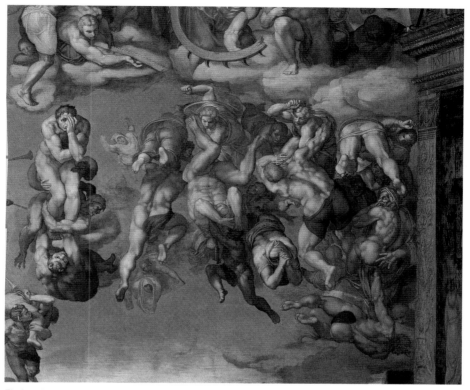

The Last Judgment, detail, 1535–41, fresco, Cappella Sistina, Musei Vaticani, Rome.

"The true work of art is but a shadow
of divine perfection."

Michelangelo

Paul III Farnese becomes Pope. He supports
the conservation of antiquities in Rome.

1534

cophagus. Two tombs and the painting of the
chapel remained unfinished.

Two days after Michelangelo moved to
Rome, Pope Clement VII died. His successor,
Paul III Farnese, elected in October, insisted
on the completion of a work commissioned

by Clement in the winter of 1533-34: a *Last
Judgment* for the altar wall of the Sistine
Chapel. Michelangelo reluctantly agreed. The
Pope released him from his obligation
to work on the *Julius Tomb*. In view of his
advanced years, Michelangelo was asked to
paint the *Last Judgment* on canvas. He

rejected the suggestion out of hand on the
grounds that oil painting was for weaklings.
From **1535–1541** he worked on the monu-
mental fresco from a scaffolding in the Sis-
tine Chapel.

Brutus, *c.* 1538, marble, 74 cm high, Museo Nazionale del Bargello, Florence.

Three Labours of Hercules, 1530, red chalk, 27.2 x 42.2 cm, Royal Library, Windsor Castle.

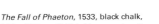

Tityos, 1532, charcoal, 19 x 33 cm, Royal Library, Windsor Castle

The Fall of Phaeton, 1533, black chalk, 31.3 x 21.7 cm, British Museum, London.

1535 Giulio Romano is put in charge of construction and decoration of the Palazzo del Te in Mantua.

1537 Cosimo I becomes Duke of Tuscany, taking the title of Grand Duke in 1569.
He has supreme authority in matters of foreign affairs, diplomacy and war, as well as

| **1535** | **1535** | **1536–1537** |

It was during these years that his social status reached its apex. On 1 September **1535** he was appointed Supreme Architect, Sculptor and Painter to the Apostolic Court. Now in the highest circles, he still counted among his closest friends many exiled Florentines who had fled to Rome. One of them, Niccolò

Ridolfi, is immortalised in the marble bust of *Brutus,* created in the late 1530s in memory of the Republican virtues.
The most important inspiration of his early years in Rome was, however, his passionate relationship with the young aristocrat Tommaso de' Cavalieri whom he idealised.

Michelangelo dedicated many poems to him as an expression of his love and admiration, and gave him several precious drawings. From **1536** onwards, his admiration for Cavalieri began to wane in favour of the highly regarded poetess Vittoria Colonna, Marchesa of Pescara. For her, too, Michelangelo wrote

Pietà for Vittoria Colonna, 1538–40, black chalk,
29.5 x 19.5 cm
Isabella Stuart Gardner Museum, Boston.

Michelangelo's plan for the Capitoline in Rome, copperplate
engraving by Etienne Duperac, 1569.

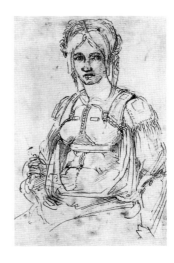

Study of a woman
(possibly Vittoria
Colonna), *c.* 1540,
chalk, British
Museum, London.

"The works of Michelangelo indisputably convey the purest and
most exalted sentiment to be experienced in art. It is as though he
sought only to delight himself, with scant regard for the beholder
and his taste. His exaggerations and inventions are not aimed
at illusion or enchantment but at harnessing the power of the
imagination in order to force pleasure by presenting images that
threaten to overwhelm and awe the mind."

Eugène Delacroix

the domestic authority to appoint officials
and determine patronage. Administration
and jurisdiction are in the hands of other old-
established families.

The Council of Trent, which forms the basis
of Catholic Counter-Reformation, meets at
three sessions between 1545 and 1563. The
Council of Trent becomes the starting point

of reforms within the Catholic church which
also have an impact on art.

1536

1541

numerous sonnets, painted sketches and
drawings. Colonna belonged to the Catholic
reform movement which was to have an
important influence on Michelangelo.
Whenever she stayed in Rome, she would
receive Michelangelo in the Gardens of
S. Silvestro on the Quirinal Hill. Together,

she and Michelangelo drew up plans for a
convent. He was also involved in a project
to redesign the Capitoline Hill with the
equestrian statue of Marcus Aurelius.
On Christmas Day **1541** the *Last Judgment*
was unveiled. In **1542** Michelangelo started
work reluctantly on painting the Pauline

Chapel in the Vatican; the *Conversion of
St Paul* and the *Crucifixion of St Peter* were
completed in 1550. In the summer of 1542,
the final agreement for the *Julius Tomb* was
concluded. Michelangelo was to deliver the
statues of *Moses* and the *Slaves* – later
replaced by *Leah* and *Rachel* – and the

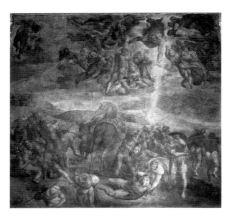

The Conversion of St Paul, c. 1542–45, fresco,
625 x 661 cm, Cappella Paolina, Musei Vaticani, Rome.

Tomb of Julius II, *Leah, c.* 1542, marble, 197 cm
high, S. Pietro in Vincoli, Rome.

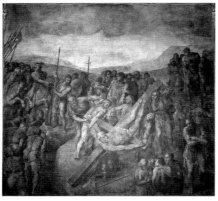

The Crucifixion of St Peter, c. 1542–45, fresco,
625 x 661 cm, Cappella Paolina, Musei Vaticani, Rome.

Tomb of Julius II, *Rachel,
c.* 1542, marble, 209 cm high,
S. Pietro in Vincoli, Rome.

1545 The first Botanical Garden is created in
Padua.

1546 Pietro Aretino creates a landmark in
Renaissance tragedy with his play *Orazia.*

1548 Giordano Bruno, the major Italian
Renaissance philosopher, is born in Nola.

1546　　　　　　　**1547**

remaining figures were to be created by Raf-
faello da Montelupo and others. The tomb
was erected in February 1545.
In October **1546** Rome's leading architect,
Antonio da Sangallo, died. Michelangelo was
now commissioned to complete the exterior
of the Palazzo Farnese designed by Sangallo.

On 1 January **1547** he was officially appointed
Chief Architect of Saint Peter's and invested
with all freedom to alter the existing design
or demolish parts of the building. In February,
Vittoria Colonna died. The loss was all the
more bitter for Michelangelo because several
other close friends had already died or

returned to Florence. In the last two decades
of his life, he became increasingly reclusive,
concentrating entirely on completing his
great task at St Peter's.

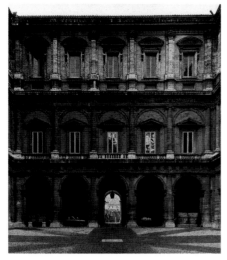

Palazzo Farnese, façade of the inner courtyard,
c. 1546–47, Palazzo Farnese, Rome.

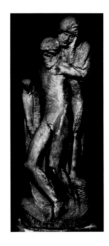

Palestrine Pietà, *c.* 1555, marble, 253 cm high, Galleria dell'
Accademia, Florence.

Rondanini Pietà, 1552–64,
marble, 195 cm high, Museo
del Castello Sforzesco,
Milan.

1550 Giovan Francesco Straparola collates the first collection of European fairy-tales. Ciocchi del Monte becomes Pope Julius III.

1551 The second session of the Council of Trent is a driving force behind the reform of the Catholic church.

Loyola founds the papal university, the *Collegium Romanum*, in Rome.
1555 Cosimo I Medici of Florence conquers Siena.

1550

1553

1553–1555

1550 he began work on the *Florentine Pietà* intended as his own funerary monument. That same year, the first edition of Vasari's *Lives of the Artists* was published; Michelangelo was the only living artist to be included in it.

In **1553** the *Life of Michelangelo* by Ascanio Condivi was published.
In **1555** he destroyed the older Pietà and began work on the *Rondanini Pietà*, which he worked on to the last, but never finished. Work on the Capitoline Hill continued until his death. Moreover, Michelangelo designed

a number of other architectural projects, such as the *Capella Sforzesca in S. Maria Maggiore*, **1559** *S. Giovanni dei Fiorentini* and the *Stairway of the Biblioteca Laurenziana*.

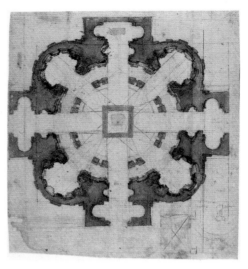

Plan for S. Giovanni dei Fiorentini, *c.* 1559, 42.8 x 38.6 cm, pencil, pen and ink, watercolour and white lead, Casa Buonarroti, Florence.

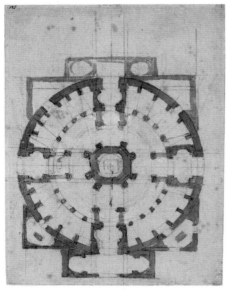

Plan for S. Giovanni dei Fiorentini, Casa Buonarroti, Florence.

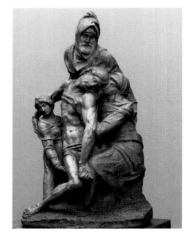

Florentine Pietà, 1550–55, marble, 226 cm high, Museo dell' Opera del Duopmo, Florence.

"Lord grant that I might always desire more
than I can accomplish."

Michelangelo

1559 Emperor Philip II grants Siena to Duke Cosimo I.

c. **1560** The 'pagan' Renaissance is waning – an indication of the Council of Trent's impact on art.

1560 Baccio Bandinelli, emulator and rival of Michelangelo, dies in Florence.

1557

1563

From about **1557** his advanced age made it impossible for him to supervise the construction work on site as fully as he would have wished. As a result, some errors occurred in the vaulting of the transept of

St Peter's. In the last years of his life, Michelangelo felt all the more strongly that he had a moral obligation to retain his position in order to prevent further such misunderstandings.

In spite of all advances from Florence, where, in **1563** he was elected director of the newly founded Accademia dell'Arte alongside Duke Cosimo I de' Medici, Michelangelo remained in Rome.

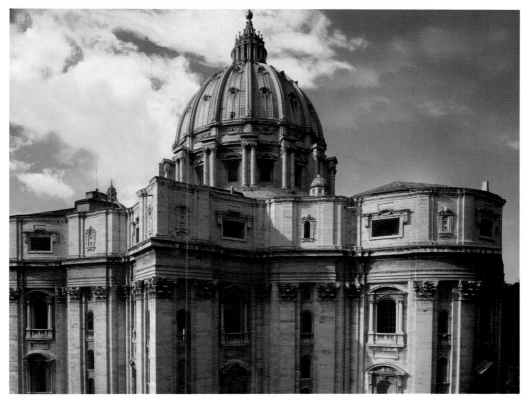

Apse of St Peter's, Vatican, Rome.

1561 Giovanni Pierluigi da Palestrina, one of the greatest masters of liturgical music of the sixteenth century, becomes choirmaster at S. Maria Maggiorre

1562 Mattheo Bandello, 'inventor' of Romeo and Julia, whose 214 influential novellas also inspired Shakespeare, dies in France.

1564

Around 14 Februar **1564** his health deteriorated, and on 18 February Michelangelo died. At his own request, his body was transferred to Florence, where the Accademia gave him a ceremonious funeral in San Lorenzo on 14 July.

LOCATIONS OF KEY WORKS

❷

❶

1
New York
The Metropolitan Museum of Art

2
Boston
Isabella Stuart Gardner Museum

3
Oxford
Ashmolean Museum

4
Windsor
Royal Library, Windsor Castle

5
London
British Museum
National Gallery
Royal Academy of Arts

6
Bruges
Onze-Lieve-Vrouw (Church of Our Lady)

7
Paris
Musée du Louvre

8
Munich
Staatliche Graphische Sammlung

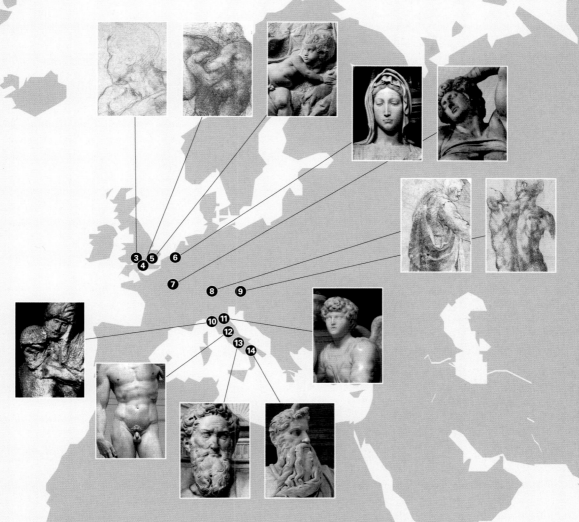

Selected Bibliography

Given that this publication is intended as a widely accessible essay, there are no footnotes. The text is not based on new scholarly findings, but on a highly selective synthesis of some five hundred years of art historical literature on Michelangelo, with the emphasis on recent research, dating and attributions. Instead of footnotes, the author provides a list of the publications on which this text is based. Standard works recommended as an introduction to the work of Michelangelo are marked with a dot •.

• Argan, Giulio C. and Bruno Contardi, *Michelangelo Architect*, New York 1993

Bardeschi Ciulich, Lucilla (ed.), *Michelangelo: grafia e biografia*, exhib. cat., Brescia 2001

Barocchi, Paola (ed.), *Il Giardino di San Marco*, exhib. cat., Florence 1992

Barolsky, Paul, "Looking at Renaissance Sculpture with Vasari," in MacHam, Satrah Blake (ed.) *Looking at Italian Renaissance Sculpture*, Cambridge 1998

Barolsky, Paul, "Michelangelo and the Image of Artist as Price," in *Basilika eikon/ Collana di studi sul Rinascimento*, 4/30–35

Campbell, Stephen J., "'Fare una Cosa Morta Parer Viva': Michelangelo, Rosso and the (Un)Divinity of Art," in *Art Bulletin* vol. 84, no. 4, December 2002

Chastel, André (ed.), *Leonardo da Vinci: Sämtliche Gemälde und die Schriften zur Malerei*, Munich 1990

• Condivi, Ascanio, *The Life of Michelangelo*, first published 1553 (see Wohl, Alice Sedgwick)

Fastenrath Wiebke, "Terribilità – Bizzaria – Capriccio: Zum Dekorationssystem der Sixtinischen Decke", in Rohlmann, Michael and Andreas Thielmann (eds.), *Michelangelo: Neue Beiträge*, Munich/Berlin 2000

Freud, Sigmund, *Der Moses des Michelangelo*, Frankfurt a. M. 1964

Girardi, Enzo N., "La mi'allegrezz'è la la malinconia," in Rotondi Secchi Tarugi, Luisa (ed.), *Malinconia ed allegrezza nel rinascimento*, Milan 1999

• Goffen, Rona, *Renaissance Rivals: Michelangelo, Leonardo, Raphael, Titian*, New Haven/London 2002

Hirst, Michael, *Michel-Ange dessinateur*, exhib. cat., Paris 1989

Hirst, Michael, *The Young Michelangelo: The Artist in Rome, 1496–1501*, exhib. cat., London 1994

Hirst, Michael, "Michelangelo in Florence: 'David' in 1503 and 'Hercules' in 1506," in *The Burlington Magazine*, no. 142, August 2000

Jacobs, Fredrika, "(Dis)assembling Marsyas, Michelangelo and the Accademia del Disegno," in *The Art Bulletin*, vol. 84, no. 3, September 2002

• Kauffmann, Georg, *Die Kunst des 16. Jahrhunderts*, Berlin 1984

• King, Ross, *Michelangelo and the Pope's Ceiling*, London 2002

Panofsky, Erwin, *Studies in Iconology Humanistic Themes in the Art of the Renaissance*, Oxford 1939

Peoletti, John T., "Michelangelo's Masks," in *Art Bulletin*, vol. 74, 1992

Poeschke, Joachim, *Die Skulptur der Renaissance in Italien*, vol. 2: *Michelangelo und seine Zeit*, Munich 1992

Robin Richmond, *Michelangelo and the Creation of the Sistine Chapel*, New York 1995

Rosenberg, Charles M., "Alfonso I d'Este and the man who bought pigs," in Neher, Gabriele (ed.), *Revaluing Renaissance art*, Aldershot 2000

Rosenberg, Raphael, *Beschreibungen und Nachzeichnungen der Skulpturen Michelangelos*, Munich 2000

Saslow, James M., "Michelangelo: Sculpture, Sex and Gender," in McHam, Sarah Blake (ed.), *Looking at Italian Renaissance Sculpture*, Cambridge 1998

Thielmann, Andreas, "Schlachten erschauen – Kentauren gebären," in *Michelangelo: Neue Beiträge*, Munich/Berlin 2000 (see also Fastenrath)

• Tolnay, Charles de, *Michelangelo*, 5 vols., Princeton [1943–60] 1969–71

• Vasari, Giorgio, *Lives of the Artists* (transl. George Bull), London 1965 (first published 1550/revised and enlarged edition 1568)

• Vecchi, Pierluigi de und Gianluigi Colalucci, *Michelangelo: The Vatican Frescoes*, New York 1997

Wallace, William E., "A Week in the Life of Michelangelo," in McHam, Sarah Blake (eds.), *Looking at Italian Renaissance Sculpture*, Cambridge 1998

• Wallace, William E., *Michelangelo: The Complete Sculpture, Painting, Architecture*, Southport 1998

• Wallace, William E., *Michelangelo at San Lorenzo: The Genius as Entrepreneur*, Cambridge 1994

Wilde, Johannes, "Michelangelo and Leonardo", in *Burlington Magazine*, no. 95, 1953

Wohl, Alice Sedwick and Helmut Wohl (transl.), *Ascanio Condivi's Life of Michelangelo*, Baton Rouge/Oxford 1976

Poems and Other Writings

The poems, sonnets, fragments of poetry and extracts from letters by Michelangelo cited in this essay are from the following translations:

Saslow, James M., *The Poetry of Michelangelo*, New Haven/London, 1992

Gilbert, Creighton (transl.) and Robert N. Linscott (ed.) *Complete Poems & Selected Letters of Michelangelo*, New York 1963

Index

157

Photographic Credits

The illustrations in this publication have been kindly
provided by the museums, institutions and archives
mentioned in the captions, or taken from the Pub-
lisher's archives, with the exception of the following:
AKG Berlin: 36,40,41 top
akg-images / Erich Lessing: 123
akg-images / Rabatti-Domingie: 50,61,81,85, 108
Archivio Buonarotti, Florence: 27, 37, 38, 41 bottom,
43
Aurelio Amendola: 3, 7, 9, 60, 68, 126
Bridgeman Art Library: 25, 31, 62, 87, 88 top, 89, 95,
133 top left
Casa Buonarotti: 93 top, 111 bottom, 152 top left /
top right
EMB-Service Luzern, Franz Gisler: 99-102
Albert Hirmer and Irmgard Ernstmeier-Hirmer: 49,
58, 59, 64, 129 right, 233, 234 right, 135 top left, 136
centre / bottom right, 137, 140, 142, 143 bottom left,
144 right, 145 right, 146 bottom left, 148 top left, 150
top right / bottom right, 151 bottom left
The Metropolitan Museum of Art: 32
© Photo SCALA, Florence, 2003: 4, 10, 16, 19, 45, 46,
47, 52, 65,66,67, 72, 75, 78, 79, 91, 92, 94, 104, 112,
113, 114, 116, 117, 118 bottom, 120, 121, 124, 125,
128 centre top / bottom right, 130, 132 left, 133 cen-
tre bottom, 136 top right, / bottom left / centre bot-
tom, 136 top right, 141, 143 top left / centre / right,
144 left, 145 bottom left, 146 top left / right, 150 top
left and bottom left, 151 right, 152 bottom right, 153
Paolo Tosi Fotografo Firenze: 51, 63, 69, 70, 71, 76,
77, 129 left
Vatican Museums, Vatican: 15,21,29,34, 39, 42, 55, 57,
82, 93 bottom, 97, 105, 106, 107, 138, 147
Front cover: Michelangelo, Detail from *The Creation
of Adam*, Sistine Chapel Ceiling
Page 32 (frontispiece): Jacopino del Conte, *Michelan-
gelo Buonarroti*, c. 1540, oil on panel, 88.3 x 64.1 cm,
The Metropolitan Museum of Art, gift of Clarence
Dillon, 1977 (1977.384.1) Photograph © 1985 The
Metropolitan Museum of Art
Page 34: Michelangelo, Detail from *The Creation of
Adam*, Sistine Chapel Ceiling (full view pages 99-
102)

© Prestel Verlag, Munich · Berlin · London ·
New York, 2010

Prestel Verlag, Munich
A member of Verlagsgruppe Random House GmbH

Prestel Verlag
Königinstrasse 9
80539 Munich
Tel. +49 (0)89 24 29 08-300
Fax +49 (0)89 24 29 08-335

www.prestel.de

Prestel Publishing Ltd.
4 Bloomsbury Place
London WC1A 2QA
Tel. +44 (0)20 7323-5004
Fax +44 (0)20 7636-8004

Prestel Publishing
900 Broadway, Suite 603
New York, NY 10003
Tel. +1 (212) 995-2720
Fax +1 (212) 995-2733

www.prestel.com

Library of Congress Control Number is available;
British Library Cataloguing-in-Publication Data: a
catalogue record for this book is available from the
British Library; Deutsche Nationalbibliothek holds a
record of this publication in the Deutsche National-
bibliografie; detailed bibliographical data can be
found under: http://dnb.d-nb.de

Prestel books are available worldwide. Please contact
your nearest bookseller or one of the above addresses
for information concerning your local distributor.

Translated from the German by Ishbel Flett
Edited by Christopher Wynne
Editorial assistence: Danko Szabó
Picture Research: Claudia Stäuble and Isabella Kuhl
Design and Layout: Horst Moser, independent
Medien-Design, Munich
Production: Astrid Wedemeyer, Miriam Horwath
Origination: ReproLine Mediateam, Munich
Printing and binding: Druckerei Uhl, Radolfzell
Bodensee

Verlagsgruppe Random House FSC-DEU
The FSC-certified paper *Hello Fat Matt 1,1* is
produced by Condat, Le Lardin Saint-Lazare, France

Printed in Germany

ISBN 978-3-7913-4472–0

Io gra facto negoze
chome fa fare
over daltro pae
cha forza luie
La barba aletelo e
rsullo scrignio e
e lfirmel sopraluiso
melfa gocciando